# GREAT GRAY OWL

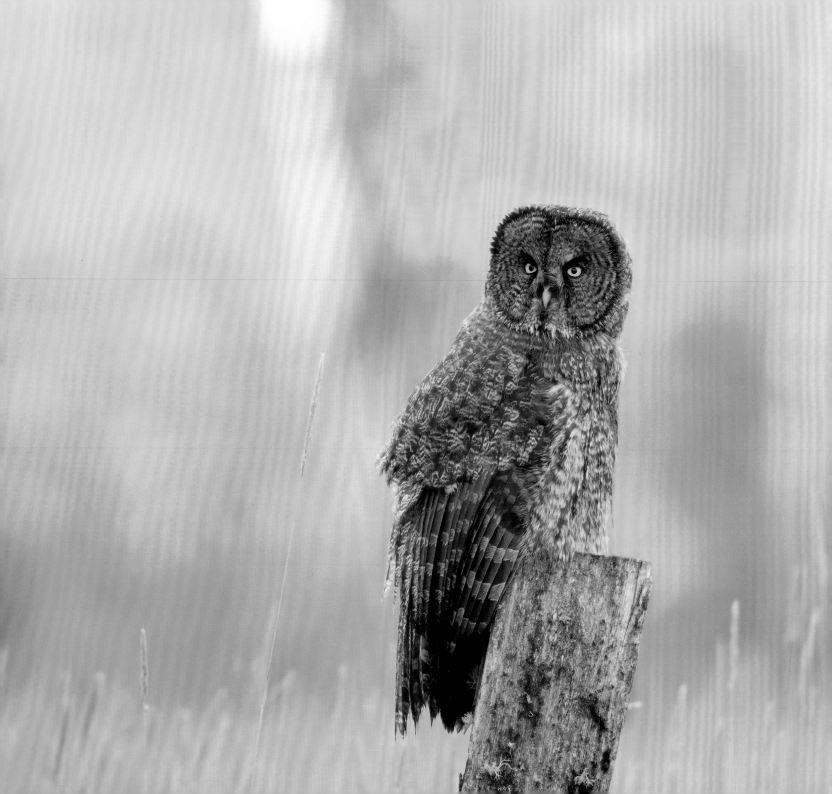

# GREAT GRAY OWL

*A Visual Natural History*   PAUL BANNICK

**MOUNTAINEERS BOOKS**

献给柏颖

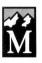

**MOUNTAINEERS BOOKS** is dedicated
to the exploration, preservation, and enjoyment
of outdoor and wilderness areas.

1001 SW Klickitat Way, Suite 201, Seattle, WA 98134
800-553-4453, www.mountaineersbooks.org

Printed in China
Distributed in the United Kingdom by Cordee, www.cordee.co.uk
23  22  21  20      1  2  3  4  5

Copyeditor: Linda Gunnarson
Design and layout: Kate Basart/Union Pageworks
All photographs by the author unless credited otherwise
Front cover, jacket: *A juvenile Great Gray Owl hovers over potential prey in its early days of independence.* Back cover,
jacket: *With his eyes glued on those of his begging mate, a male Great Gray Owl waits for the right moment to deliver a
chipmunk to her.* Front flap: *As the sun sets, a female and her nestlings wait silently for any sign of the male arriving with
food.* Frontispiece: *Aspens in peak fall color form a backdrop for this juvenile Great Gray Owl. Juveniles gain their
independence slowly but are usually on their own by mid-autumn.* Facing page: *Great Gray Owls, like this adult male, usually
hunt in large openings adjacent to mature forests. It is difficult to distinguish the sex of this species, but I knew this was a male
because the female was no longer attending to the young.* Page 128: *A few days after leaving the nest, young Great Gray Owls are
capable of climbing small stumps and leaning trees from where they practice short flights or beg to be fed.*

Library of Congress Cataloging-in-Publication Data is on file at https://lccn.loc.gov/2020016604

Mountaineers Books titles may be purchased for corporate, educational, or other promotional sales, and our authors
are available for a wide range of events. For information on special discounts or booking an author, contact our
customer service at 800-553-4453 or mbooks@mountaineersbooks.org.

Printed on FSC®-certified materials

MIX
Paper from
responsible sources
FSC® C008047

ISBN: 978-1-68051-335-6

*An independent nonprofit publisher since 1960*

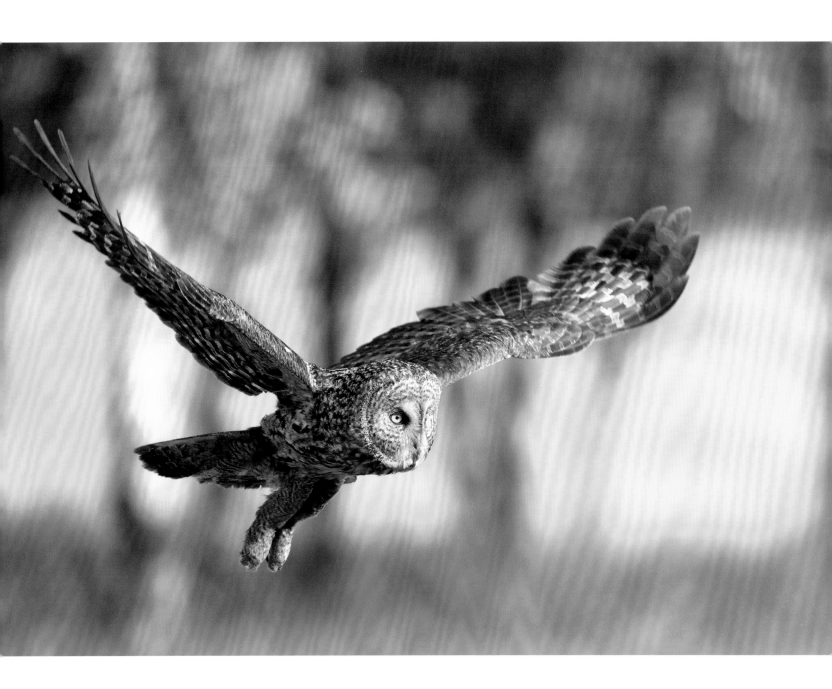

# Preface

*Great Gray Owls' large frames make their frequent choice of tiny perches surprising until we consider their relatively light weight and small feet.*

One of my earliest encounters with a Great Gray Owl took place one frigid morning in northern Minnesota, just before the sun rose and well before the air temperature climbed to 10 degrees Fahrenheit. I would learn over the next fifteen years that even when you try your hardest to find a Great Gray—in the places and at the times that offer the best chances—you usually fail. To succeed, you often must strain your eyes to spot them in low-light conditions before dawn and endure bone-chilling temperatures.

If you do encounter a Great Gray Owl, it may be extremely tolerant if you are quiet, stay as still as you can, and do not pursue it. Perhaps the owl will ignore your presence and go about its natural behavior as the one I saw did on that cold winter day years ago. You should never take those moments for granted, as they are often unpredictable and fleeting. They also can stir your curiosity. The captivating behavior I witnessed on that icy day inspired me to find, observe, and capture images of Great Gray Owls throughout the four seasons of the year and through all the stages of their lives in order to gain and share a greater understanding of these charismatic creatures. I hope the photographs, natural history, and field experiences you find in this book inspire you to learn more about the Great Gray and to help educate and motivate others to protect this mysterious owl and the landscapes that it animates.

—Paul Bannick
Seattle, Washington

*During the winter, Great Gray Owls require a larger area to meet their needs and often spend time in places where they may not be seen during the spring and summer, such as ranches, farms, and public lands.*

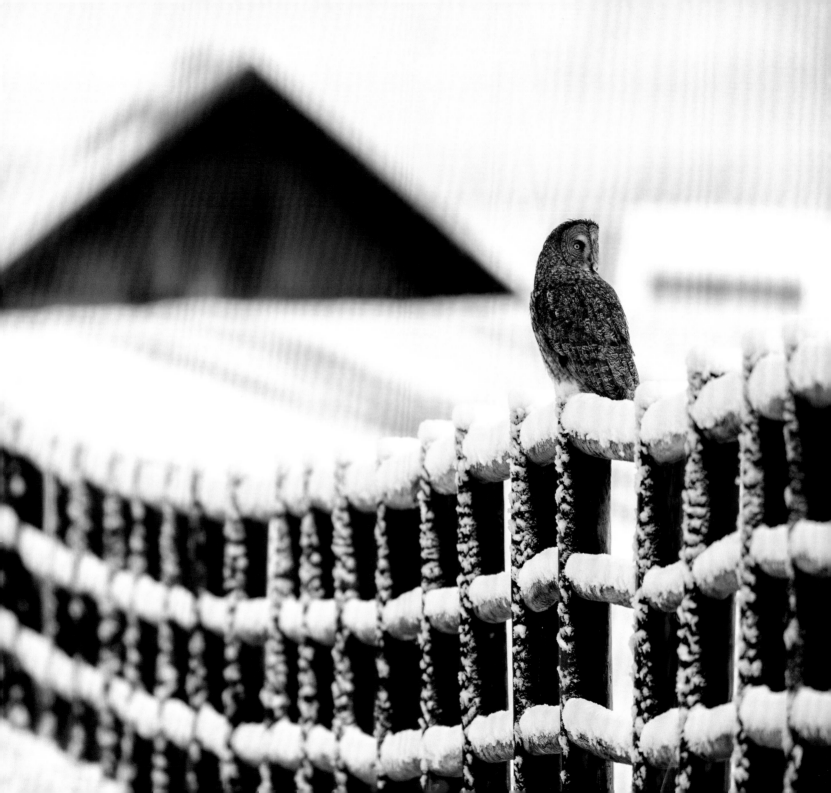

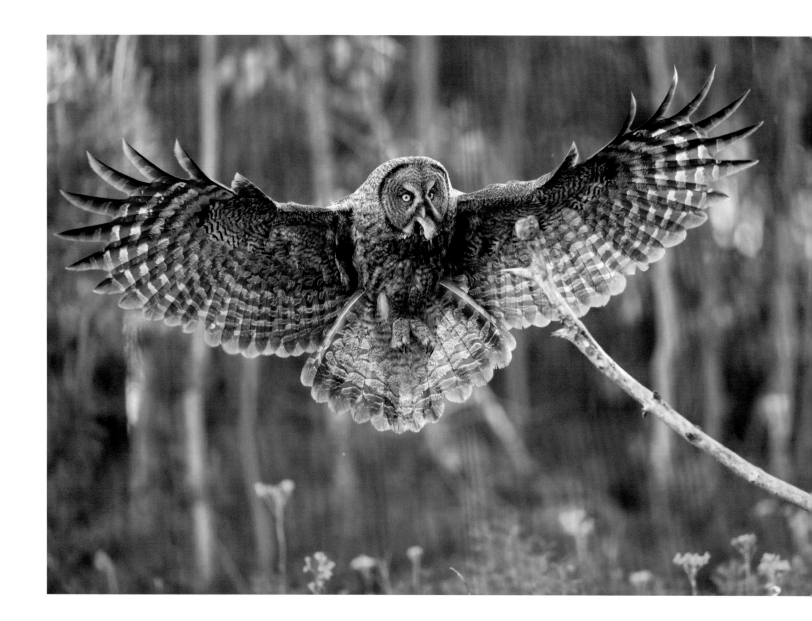

# THE GREAT GRAY GHOST

The dark shape took form as it drifted silently from a tangle of aspens. I had come to Minnesota to find the Great Gray Owl but had not imagined such a large bird could fly so slowly without falling to the ground. As it floated toward me at eye level—a stern countenance on still, horizontal wings—I could not help but focus on its golden eyes. They were bright and piercing, as if lit by fire, striking in their stark contrast to the otherwise soft roundness of the immense face, which obscured the rest of the owl's body. Those blazing eyes glowed as if they were the engine of an otherwise passive gliding ghost.

I scanned the snow-covered meadow, searching for the owl's prey, but saw nothing. Suddenly the owl slammed violently into the snow, seemingly face-first, directly in front of me and looked for a moment like a disheveled, lifeless pile of gray, brown, and white feathers. Slowly the owl shape reassembled. Looking stunned, with its snow-covered face peering downward, the owl sank, until only its head and shoulders were visible above the white blanket. Its talons and feet dug deep and emerged with a large vole, which the bird consumed with a few open-billed jerks of the head. Before I could contemplate what had happened, the owl took flight in a spray of snow, dissolving back into the dense cluster of gray-and-white aspens and leaving only an imprint of clenched feet, wings, and feathers in a depression in the snow.

Plunging my boots into the two-foot-deep drifts, I headed toward what I imagined would be a window in the aspens large enough to accommodate the huge owl's nearly five-foot wingspan. I was dismayed to find no such opening but instead a continuous web of branches and trunks. I traced the edge of the woods, guessing that the owl would be back to hunt soon, but had no luck.

Only hours later, when I reversed course and had the light at my back, was I able to discern—barely—the outline of the Great Gray's oversized head, round in the

*Male Great Gray Owls do the majority of the hunting for the family. They usually consume smaller prey such as this recently captured shrew and bring larger prey such as voles and gophers back to their mate and young.*

back and flat in the front, like half a melon, and its large body perched on a thin aspen branch. The twigs scarcely moved as the Great Gray lifted its wings and dropped low over the meadow, holding its head down and positioning its face nearly parallel to the ground. The gentle, effortless floating with no perceptible movement of wings or tail was followed by another sudden plunge into the snow. Again I witnessed the pile of feathers, long pause, the sinking into the snow, and jerky gulping of a rodent. I watched as the owl flew back into the forest just feet from where I stood, impressed by the way it pulled its wings close to its body and somehow threaded through the tight weave of the trees, disappearing, ghost-like, from my view.

Later, after reviewing my photographs and conducting more research, I learned to interpret what I had seen. The owl's eyes, which had seemed so significant in my mind, are in fact relatively small for an owl. The Great Gray uses its sensitive hearing to locate prey hidden beneath the surface of the snow. The prey never hears the owl because it flies nearly silently. Contrary to how it had appeared to me on that first sighting, the Great Gray doesn't break the snow with its face but rotates its long legs and clenched talons forward at the last instant to punch a hole in the snow, trapping its unseen prey. When the owl appears stunned, it is actually using its talons to secure the prey before consuming it or taking flight.

My investigations also answered the question of how such a large owl manages to maneuver through dense forests. Although the Great Gray possesses a huge frame, it is composed mostly of soft, flexible feathers that easily bend if they come into contact with branches, allowing the owl to squeeze through narrow gaps.

The Great Gray Owl (*Strix nebulosa*) is the largest member of the genus *Strix* and the only one that inhabits both North America and Eurasia. Despite its broad distribution, it is a mysterious owl, given its predilection for being most active during the darkest hours and often in the most inaccessible places. Great Grays are rarely seen outside their irregular irruptions (also known as invasions), but when large numbers do show up in unexpected locations, the event often draws hundreds of spectators.

*Great Gray Owls are able to plunge their feet and legs through deep snow to capture heard but unseen prey. The raised wings and tail of this particular owl hint at the depth of the prey beneath the snow.*

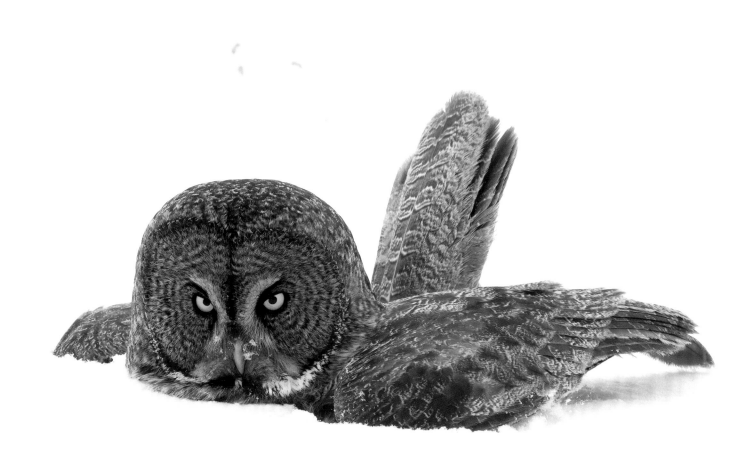

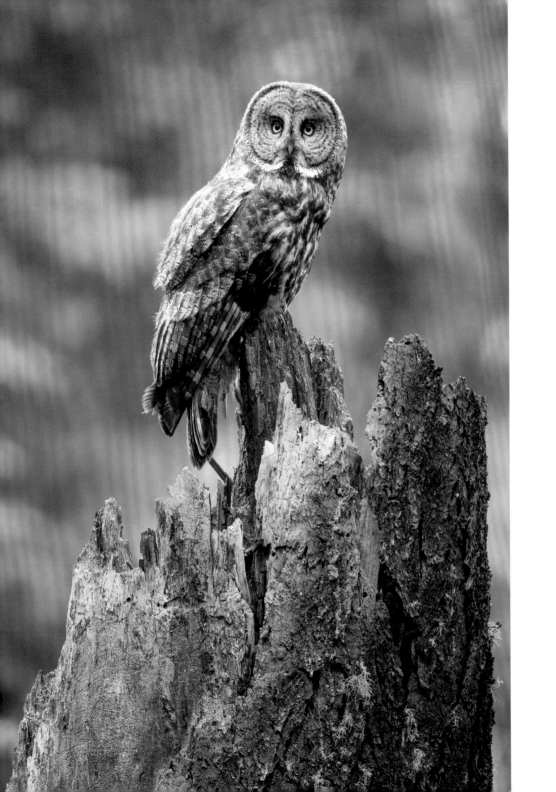

*Standing dead trees, or snags, are an important habitat element for Great Gray Owls and serve as nest sites, hunting perches, and safe retreats for young.*

The Great Gray's species name, *nebulosa,* which means "cloudy" or "foggy," hints at the mysterious appearance and behavior of this animal, earning it the nicknames "Phantom of the North," "Lapland Owl," "Bearded Owl," and "Great Gray Ghost"—the last one being my favorite.

As with other owls, we tend to fill in the gaps in our knowledge about the Great Gray Owl with assumptions, anthropomorphization, folklore, and myths. Thankfully, research has led to a greater understanding of this owl and its important role as an indicator species for the dense boreal forests that stretch across the northern parts of the globe and extend south into some mature mountain conifer forests of western North America and Eurasia. An indicator species is one whose presence and relative abundance assists in evaluating the health of an ecosystem. So understanding Great Gray Owls and preserving their habitats help us protect a variety of other species, which in North America might include Boreal Owls, Northern Hawk Owls, Spotted Owls, Northern Goshawks, woodland caribou, elk, fishers, grizzly bears, wolves, and lynx.

If we study what is fruitful for the Great Gray about the interplay between the shelter of ancient forests and the bounty of large, treeless openings then we also deepen our knowledge about the rich web of life that thrives there.

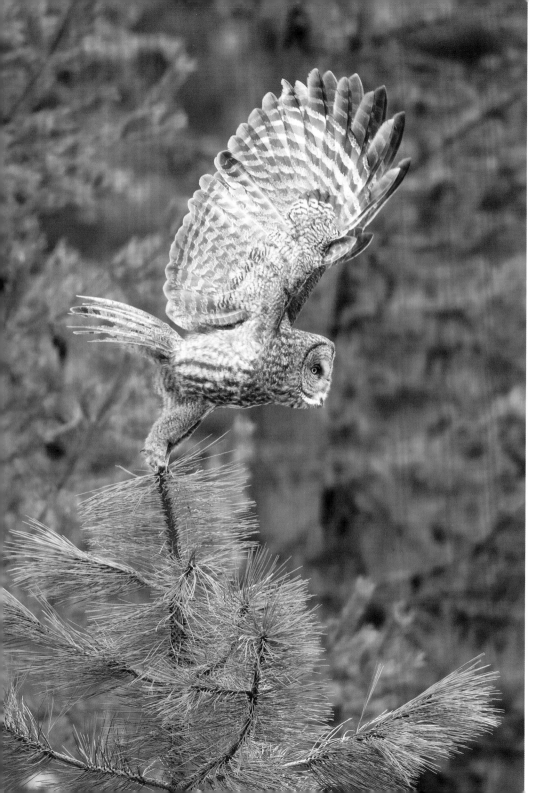

LEFT: *The Great Gray Owl is large but light, allowing it to lift itself from a thin limb with barely a response from the branch.*

OPPOSITE: *Fledgling Great Gray Owls, like these two, can be quite social and will often perch or sleep near one another.*

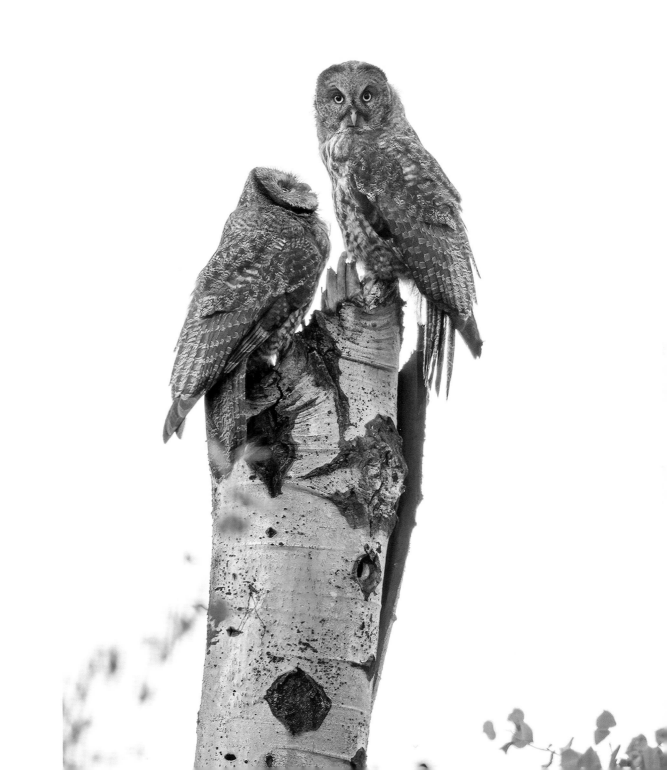

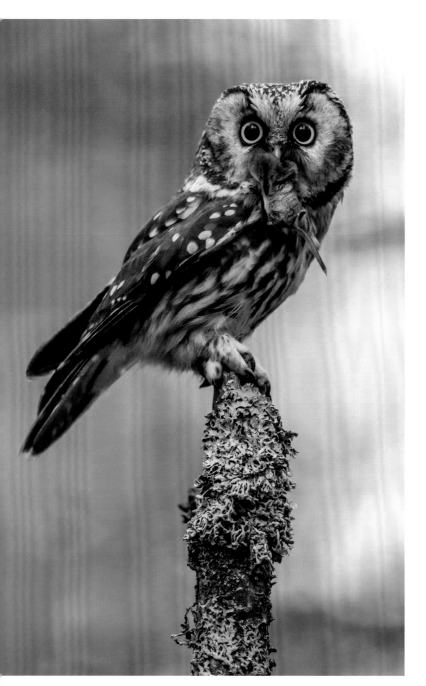
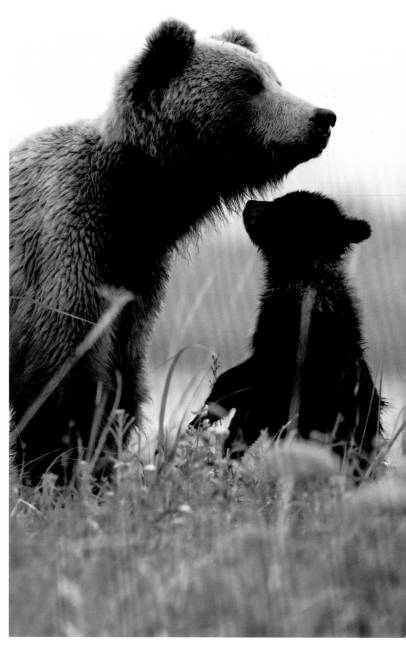

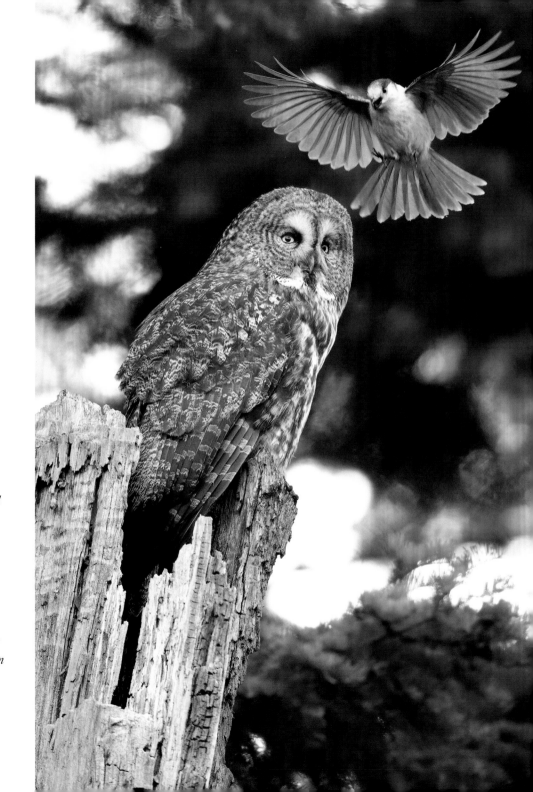

RIGHT: *A Canada Jay attacks a calling Great Gray Owl. Owls occasionally feed upon birds and their young, so many bird species instinctively attack to drive them away and to teach inexperienced birds of the danger.*

OPPOSITE, LEFT: *A Boreal Owl with a recently captured shrew in his bill looks toward his nest and the waiting young. Boreal Owls are found in dense stands of spruce within Great Gray Owl habitat in the boreal forest, but in the western United States they are typically found at higher elevations than Great Grays.*

OPPOSITE, RIGHT: *Grizzly bears are native to many of the same mature forests and open meadows preferred by Great Gray Owls across the northern and western part of their range. Grizzlies were extirpated throughout much of the southern part of their range but remain in parts of Alaska, Canada, and some northern states and may be reintroduced to others.*

*A Great Gray Owl rises up at the edge of a river to float just above the tallest grass. Great Grays often fly low to the ground, which allows them to hear prey but also makes them vulnerable to collisions with vehicles.*

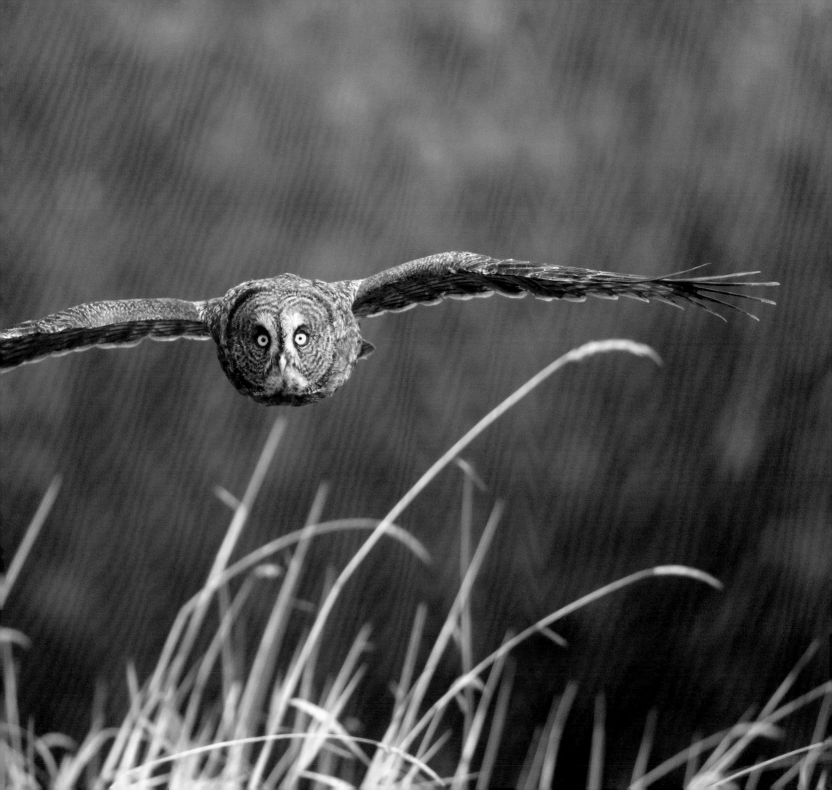

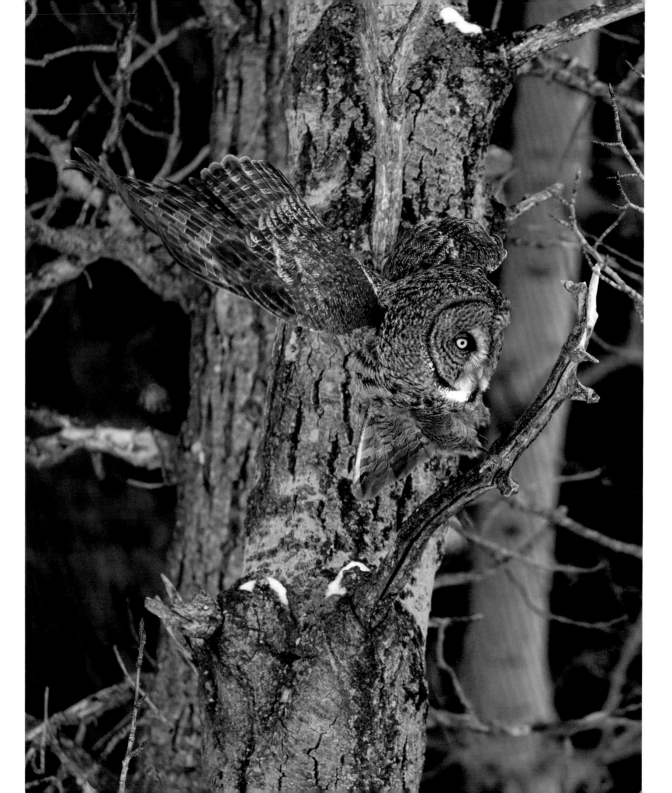

# PHYSICAL FEATURES

The Great Gray Owl is a large owl with a distinctive round facial disk featuring subtle fine barring in several concentric circles of gray and brown on a white background. On its neck, just below the yellow or, rarely, ivory-colored bill, is a small black patch bordered by two elongated white patches, which form what is often called a "bow tie." The gray "eyebrows" give the impression of a surprised face. While its eyes are relatively small, the owl's eyesight is keen and, along with its exceptional hearing, makes it a successful hunter. The Great Gray appears gray from a distance, but its coloration includes a significant amount of brown or grayish brown, particularly on the tail and wing feathers, which tend to become browner with age. This coloration provides camouflage across a wide range of forest types, whether the dominant trees are fir, spruce, cottonwood, aspen, or pine. Male and female Great Gray Owls look very much alike except that females are on average 30 to 40 percent heavier than males.

The Great Gray is often described as an "earless owl" since it lacks distinctive ear tufts like those of the Great Horned Owl, but as with other owls, the true ears are feather-covered openings on either side of the skull. The Great Gray Owl's ears are asymmetrical in both size and position on the skull, with the left ear tilted upward more than the right, enabling the owl to better pinpoint the location of prey in three dimensions.

The peculiar shape of the Great Gray gives it the appearance of a flying log. The legs are long but are often hidden by feathers when in flight or perched, and the distinctive foot-long tail is broad and wedge-shaped. In flight, from the side, the head appears oversized, and the body tapers from the broad head to the thinner torso and long tail.

The impressive ability of this large-framed owl to appear or vanish in the time it takes to turn your head or even blink is one reason I prefer to call it the Great

*Remarkable camouflage hides the Great Gray Owl from our view, even when it is flying. This combined with its secretive nature, preference for hours of low light, and ability to compress its wings and feathers to fit through small forest openings, make the Great Gray difficult to find and earns it such nicknames as "Phantom of the North."*

Gray Ghost. It seems to know where to perch to best blend in with the bark of a tree at any given time of day and will close its eyes or even slightly fold its facial disk to make its disguise more complete. If the owl hears or sees a predator, it may suddenly compress its feathers and appear stick-like against a tree. I will never forget the experience of trying to revisit the first Great Gray Owl nest that I found. Although I knew exactly where the nest was and where the male liked to perch in relation to it, it often took me several minutes of concentrated searching to spot the male or the top of the head of the brooding female in the nest.

The Great Gray Owl is often referred to as the largest owl in North America. It would appear to be the largest if perched alongside the other North American owls. With a length of up to 33 inches it is the longest-bodied owl; in mass, the smallest Great Gray males are roughly equivalent to the largest female Barred Owls. Its wingspan, which can reach up to 60 inches, is actually similar to that of Snowy Owls and Great Horned Owls. However, its maximum weight of 3.75 pounds is only roughly 60 percent the weight of the heaviest Snowy Owls and 70 percent the weight of Great Horned Owls, which share its range. The Great Gray Owl's apparent mass comes from a very generous supply of feathers on a large frame, providing insulation that allows this owl to survive frigid northern winters.

The Barred Owl is the only owl likely to be mistaken for the Great Gray Owl in North America, as both are large, gray, and round-headed (neither has ear tufts) and live in forested habitats. But the Great Gray is larger, with yellow eyes, as opposed to the dark brown eyes of the Barred Owl, and the Great Gray's eyes appear smaller relative to its overall body size. The head and facial disk appear as more prominent parts of the Great Gray's body than for the Barred, and the adult Great Gray also possesses the distinctive bow tie on its neck, which helps differentiate the two birds.

## Subspecies

There are three subspecies of the Great Gray Owl worldwide. Two of the three subspecies live in North America. *Strix nebulosa nebulosa*, the focus of this book, breeds

*The recently described Yosemite subspecies of Great Gray Owls is reported by some to be smaller and grayer than average, but has a life history very much the same as populations in the mostly southwesterly part of its North American range, including the tendency to nest in the broken tops of trees versus abandoned raptor nests or other structures. This subspecies is protected as "endangered" by the state of California.*

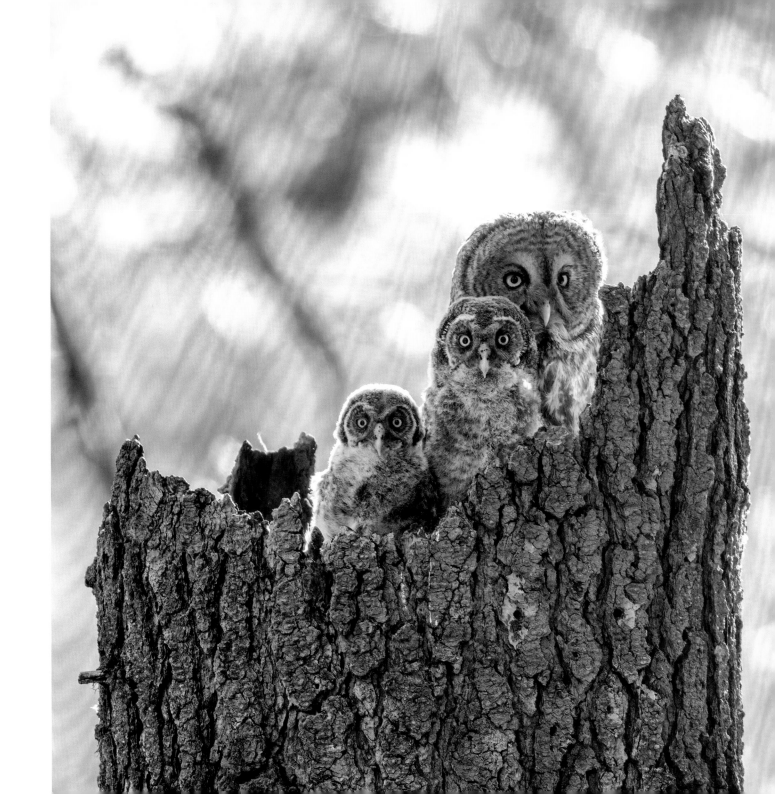

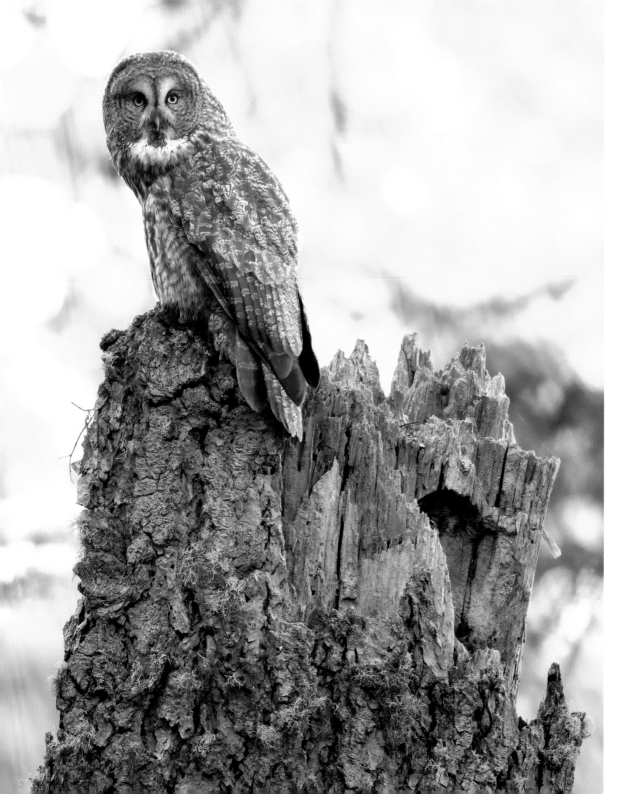

*Advertising Great Gray Owls fill their throats with air, making the white on their throats more prominent, and lean forward from a vertical posture with each note.*

in the boreal forests of Canada, Alaska, and the northernmost United States and in extensions of boreal habitat in the western mountains. The recently described (in 2014) endangered Yosemite subspecies, *Strix nebulosa yosemitensis,* includes roughly 150 individuals in and around Yosemite National Park. The Eurasian subspecies, *Strix nebulosa lapponica,* is slightly larger and significantly lighter in color than the North American Great Grays.

## Vocalizations

Great Gray Owls have several basic calls, each with subtle variations. As with most other owl species, the male's calls are deeper than the female's. Although Great Gray calls are not dramatically loud and do not carry far, I find the male's particularly deep and earthy calls are almost felt as much as heard, as though they pulse from the woods surrounding the owl.

The territorial, or advertising, call is used to attract mates and defend a territory. It occurs most frequently in the early spring during courtship and near the nest. It is a deep but muffled *hoo, hoo, hoo* lasting several seconds, with a half second between each repetition and the first note being deeper, and can be mistaken for the hoots of a Sooty Grouse.

The basic contact call between the male and female is a two-syllable *whoo-up* repeated about once per second, and a variation of it is also used by the female to beg for food from the nest. Young owls beg *eeesshk* with a raspy, ascending screech that falls off suddenly at the end. In food exchanges, both between two adults and between an adult and its young, the owls make an animated chittering call. Finally, when an owl feels threatened, it snaps its bill and hisses. Adults make a loud, high-pitched series of calls that range from chitters to screams to distract would-be predators away from their young.

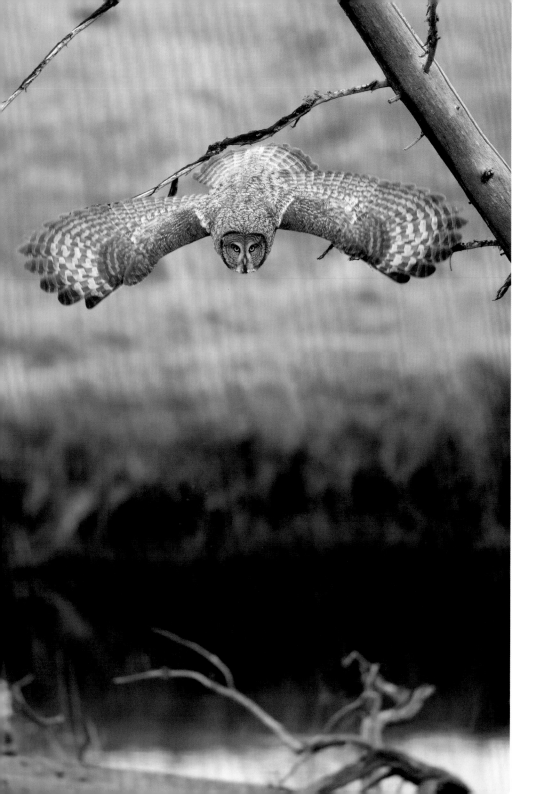

LEFT: *The tremendous surface area of a Great Gray Owl's wings and tail combined with its relatively light weight give it great buoyancy in flight. Adding nearly silent flight and keen hearing makes it a lethal hunter.*

OPPOSITE: *The cryptic pattern of gray, brown, and white feathers allow the Great Gray to disappear against the bark of a wide variety of tree species such as birch, aspen, fir, pine, and tamarack.*

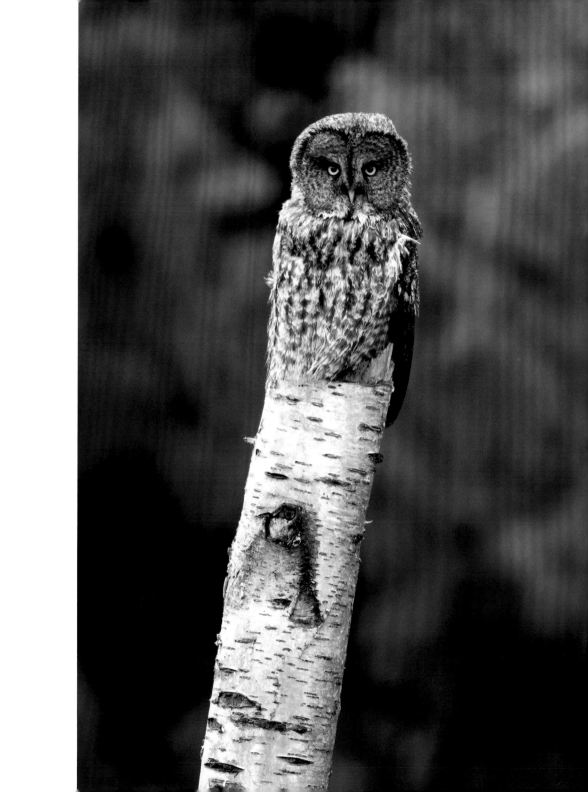

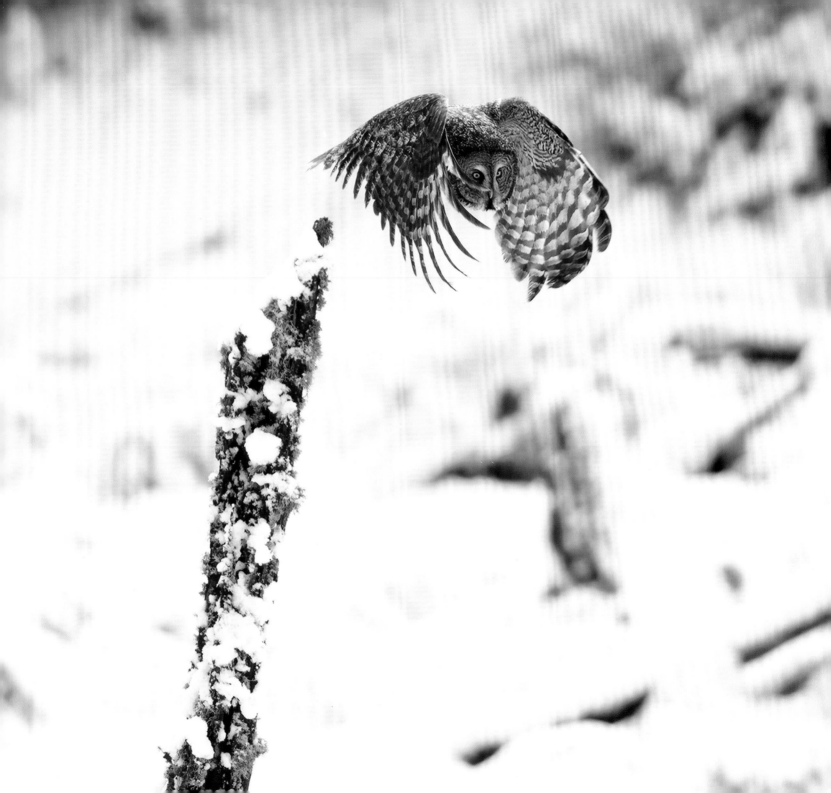

*A Great Gray Owl may sit on a perch for several minutes, or even hours, scanning the landscape with barely any movement other than the slow, deliberate swivel of its head, only to stiffen and suddenly burst toward its prey.*

# RANGE, HABITAT, & MOVEMENTS

**M**ost Great Gray Owls breed in the circumpolar boreal—or taiga—forests of North America and Eurasia. These forests feature slow-growing spruce and other conifers mixed with cottonwood, aspen, birch, and other deciduous trees, interspersed with openings in the form of meadows, recently burned areas, muskegs, bogs, lakes, and rivers.

In North America, Great Grays breed in Canada, including some forested regions of the Yukon, British Columbia, Alberta, Saskatchewan, Ontario, and Quebec; in the northernmost United States (including central and southern Alaska, northern Wisconsin, and Minnesota); and in the mountains of northwestern and north-central Wyoming, western Montana, northern Idaho, Washington, Oregon, and into east-central California, and west-central Nevada.

Great Gray Owls in Eurasia breed from northern Scandinavia through northern Russia and Siberia and south to northern parts of China, Mongolia, and Kazakhstan.

Within these broad breeding ranges, Great Grays are unevenly distributed and move or forgo breeding when prey populations are low. This pattern is especially pronounced with Great Grays in the boreal forests of their North American range, whereas in the mountains of western North America, the owls' movements and breeding are more consistent from year to year.

## Breeding Habitat

The Great Gray Owl's breeding success depends on its ability to find sufficient prey species and proper nesting sites, so those two factors determine its choice of

*A female is about to collide with her prey-delivering mate as they arrive at a small perch within moments of one another. Meanwhile, in the background, two nestlings await the prey from their nest in the broken top of a snag.*

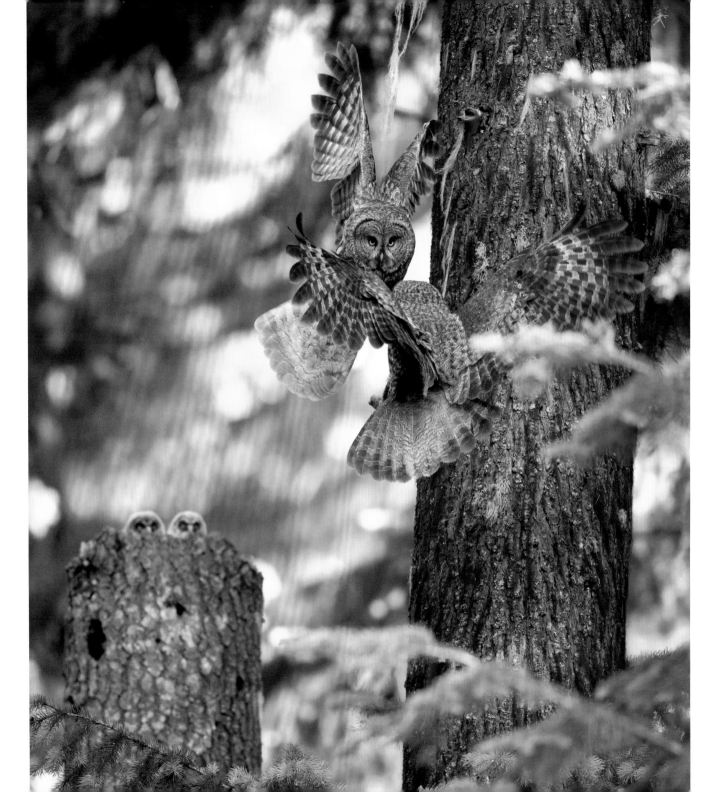

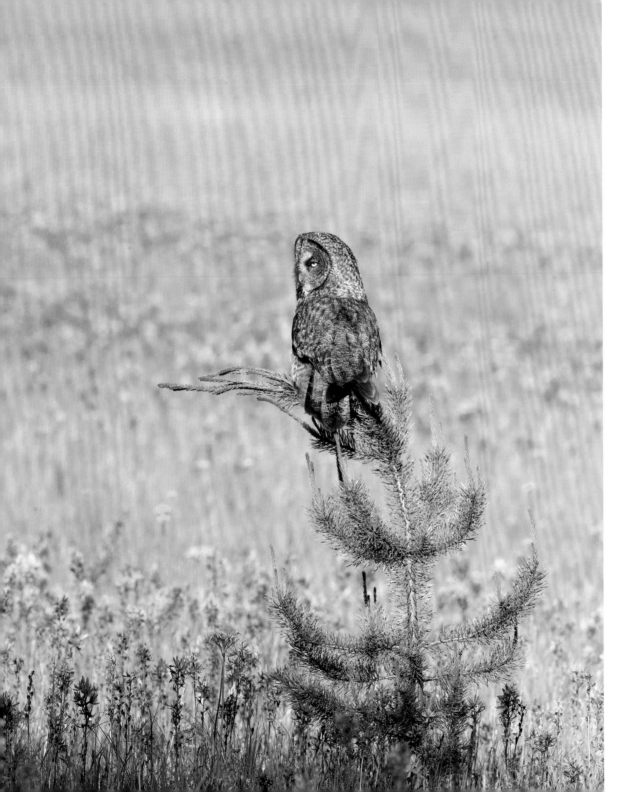

breeding habitat more than anything else. Meeting those needs necessitates finding a particular forest structure. Great Grays require mature forests, with large-diameter trees for nesting, adjacent to large, treeless areas with strong populations of voles or pocket gophers. Ideally, the forest has leaning trees that enable the flightless young to get off the ground after leaving the nest and a closed canopy to protect them from avian predators. Target prey is most abundant when the forest has a herbaceous or grassy understory and easier to catch when the owls' hunting path is not impeded by shrubs or branches.

Provided these structural needs are met, the species of tree or type of forest opening is not as important. In North America, spruce, cottonwood, and aspen forest mixes are common at nesting areas in the north; hardwoods and tamarack are more typical in eastern areas; and pine and fir stands are more common in the western mountains. The forest openings may be bogs, muskegs, wetlands, or sedge meadows in the lowlands, and meadows or even open, grassy woodlands in the mountains. Great Grays normally pursue prey within about 350 feet of a perch so the open areas best for hunting have irregularly shaped perimeters, with fingers of forest or snags (standing dead trees) extending into the opening, allowing the owls to access more of the open space.

Like all owl species, the Great Gray relies upon its ability to hide from potential predators, both while nesting and roosting. Its cryptic coloration and patterning of browns, grays, and whites that enable it to blend into a variety of forest types work especially well in fairly dense forests, whether a thick grove of aspens and cottonwoods or a pine-fir forest where it can hide in the shadows. The bird may also compress its body, which disguises its owl shape and allows it to hide behind trees. Additionally, its small eyes are easily missed.

As is true with most owls, the Great Gray does not create its own nests. Smaller owls can nest inside trees, but at almost three feet long, the Great Gray chooses nesting sites that provide camouflage and enough height to conceal its entire body. It will often nest in trees forty to seventy feet high in nests abandoned by other birds or atop a natural or artificial platform.

*Great Gray Owls often sit close to the ground while hunting, which allows them to better hear prey moving below them.*

LEFT: *Great Gray Owl hunting habitat features broad openings with unobstructed ground— such as meadows, wetlands, or muskegs—dotted with snags or small trees from which to hunt.*

OPPOSITE: *Caribou habitat overlaps with Great Gray habitat in the boreal forest and in a small part of British Columbia and Washington State.*

## Seasonal Movements and Irruptions

Owls occupy home ranges that possess the characteristics necessary for them to meet their seasonal needs. Winter home ranges may differ from summer home ranges since the first is chosen by owls based on its food supply and the second for both food supply and nest sites. Within a home range are territories, which are defended areas centered on nest sites or productive feeding areas.

Great Grays do not migrate in the traditional sense of moving annually between the same specific breeding and winter home ranges, but they often move opportunistically to areas with more abundant prey populations. Depending upon the availability of prey and the weather, Great Gray Owls may remain in their breeding home ranges, expand their home ranges, or move between home ranges that are as far as five hundred miles apart. During the winter, they can be irruptive—moving outside those ranges in unusually large numbers to places they normally don't inhabit.

There are marked differences between the movements of boreal Great Gray populations in Canada and Alaska and the movements of populations in the western mountains of the United States. The Great Gray Owls of the western mountains enlarge their home range during the winter but do not irrupt like their boreal counterparts, likely due to their ability to hunt both voles and pocket gophers, depending on availability, and their ability to easily locate areas with thinner snow cover or more abundant prey by temporarily moving a short distance downslope. Thus, the western owls are much less likely to show up outside their home ranges. In fact, many Great Grays in the western mountains may not travel more than thirty miles from their nest sites throughout an entire year, while a boreal Great Gray Owl may travel that far in a single day during an irruption.

Irruptions occur only in the eastern part of the Great Gray's range and only when vole populations are low. During these irruptions, up to several dozen Great Gray Owls may appear in places where you would normally be hard pressed to find any, such as within the Great Lakes region, southern Ontario and Quebec, and, to a lesser extent, New England. Irrupting Great Grays often fly as far as three hundred

*While they can be seen at any time of the day, Great Gray Owls are most active during the night and at dawn and dusk.*

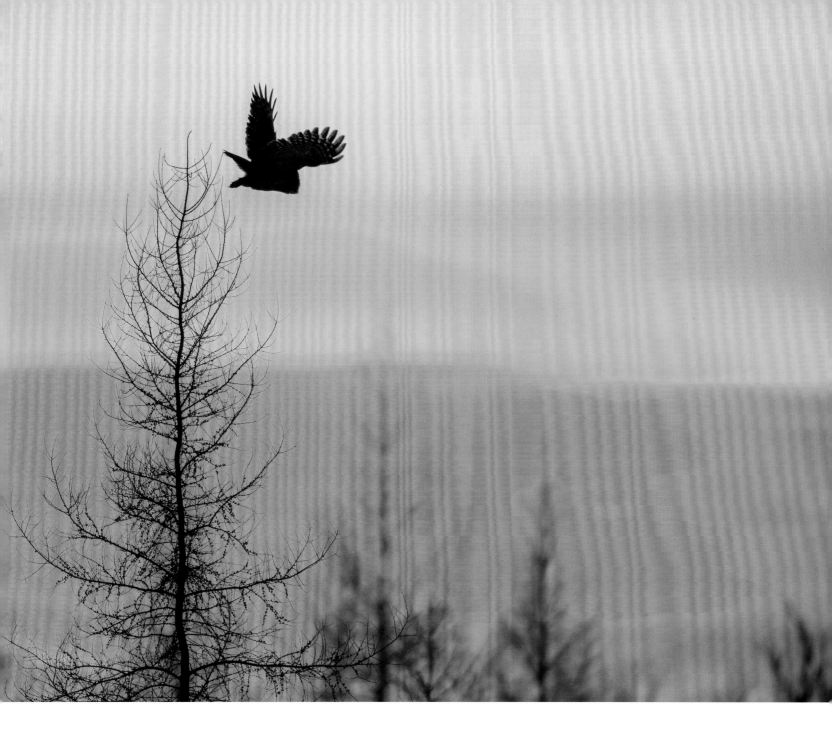

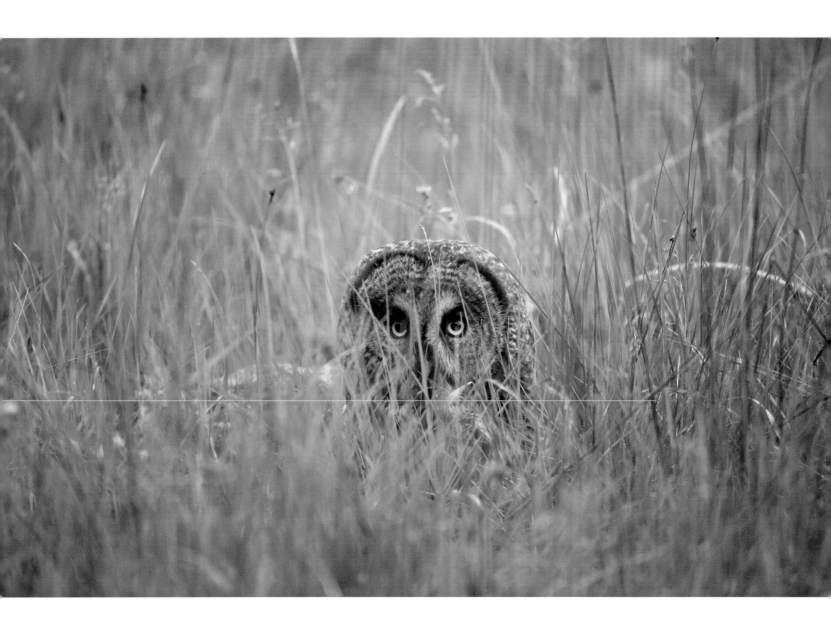

*Great Gray Owls capture much of their prey in grassy forest openings, often disappearing into the vegetation as they secure their prey and reappearing only when they take flight.*

miles south of their usual breeding range and may travel up to twenty-four miles each night. The causes of owl irruptions are often debated, but for Great Gray Owls this phenomenon appears to be most closely related to availability of prey. Irrupting Great Gray Owls are generally adults and arrive in places where prey is more abundant, while Snowy Owl irruptions often follow an extremely productive breeding season and are comprised predominantly of juvenile owls. In the winter, food takes precedence over nesting or shelter, so irrupting Great Grays prioritize the best vole habitat—open landscapes with widely spaced trees rather than denser forests. Irrupting owls die at significantly higher rates, most often as a result of collisions with vehicles. Those that survive return to their breeding territories late in the winter or early in the spring when prey populations rebound.

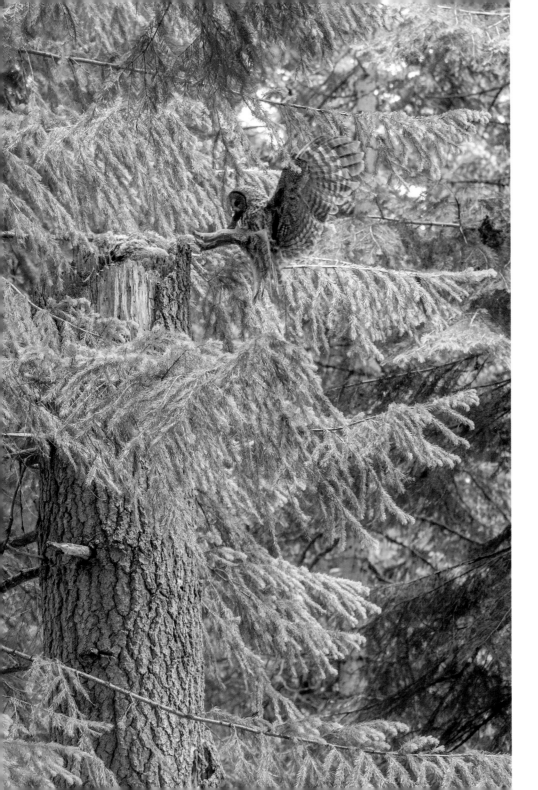

LEFT: *Large, well-decayed, broken-topped snags of forty feet or taller are more common in the western United States than elsewhere in the Great Gray Owl's range.*

OPPOSITE: *When nestlings are small, the female tears prey into smaller pieces, but as they near fledging, they are left with whole voles or gophers like the one in this nestling's bill.*

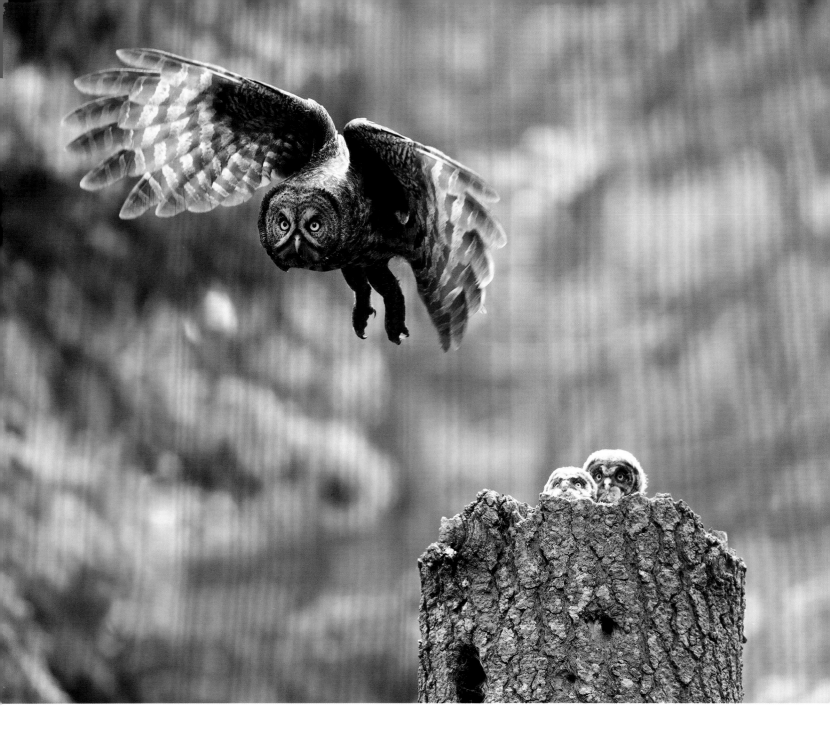

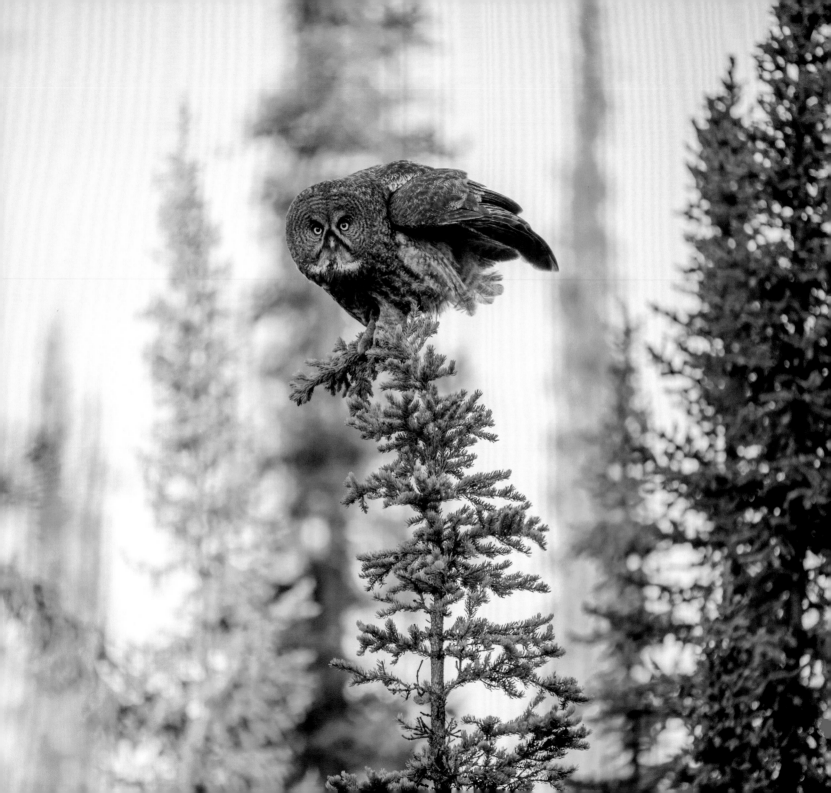

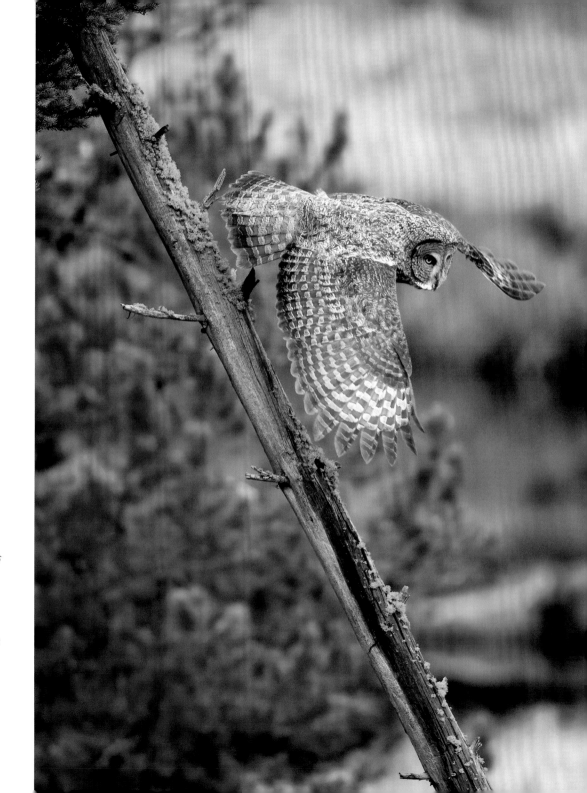

RIGHT: *Leaning trees and snags are utilized as hunting perches by adults and as easily climbed retreats by flightless young.*

OPPOSITE: *Just before a Great Gray Owl takes flight toward prey, its body freezes as it prepares to lift its wings.*

TOP: *The range and habitat of Northern Hawk Owls overlaps with Great Gray Owls from the northern boreal forest south into a few of the northernmost states.*

BOTTOM: *The fisher is a member of the mustelid family that includes weasels and wolverines and lives in mature forests with large snags. They are found across portions of the Great Gray Owl's range in boreal forests as well as parts of the Rocky Mountains and Cascades.*

OPPOSITE: *Great Gray Owls often initiate their pursuit of prey by lifting their wings straight up before floating off of a perch and over the surrounding landscape.*

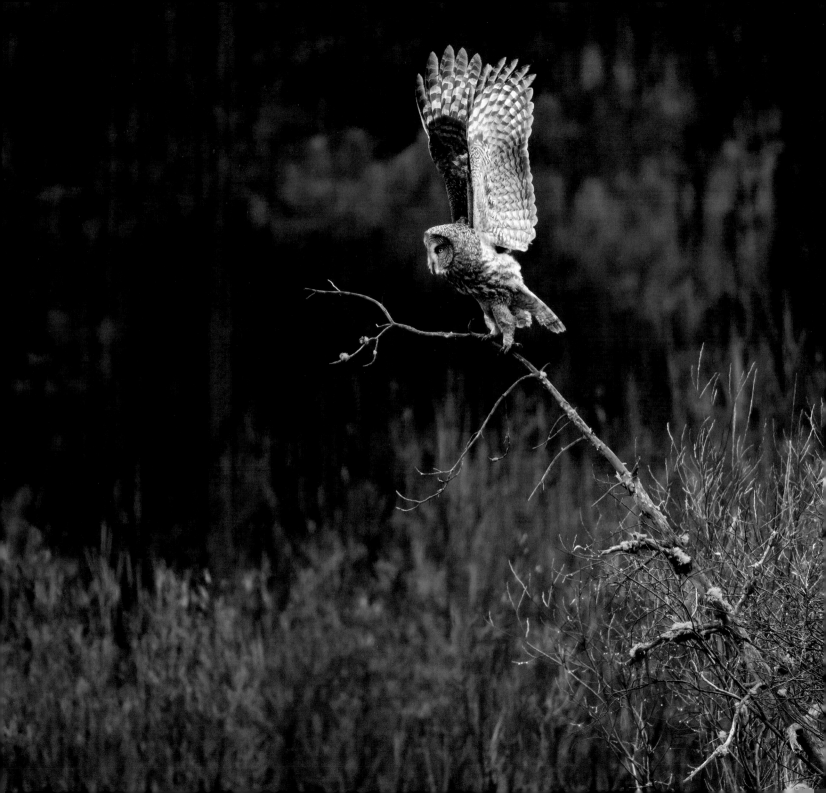

*In the western states, Great Gray Owl habitat is primarily restricted to mountainous areas where mature forests are interspersed with large openings such as meadows.*

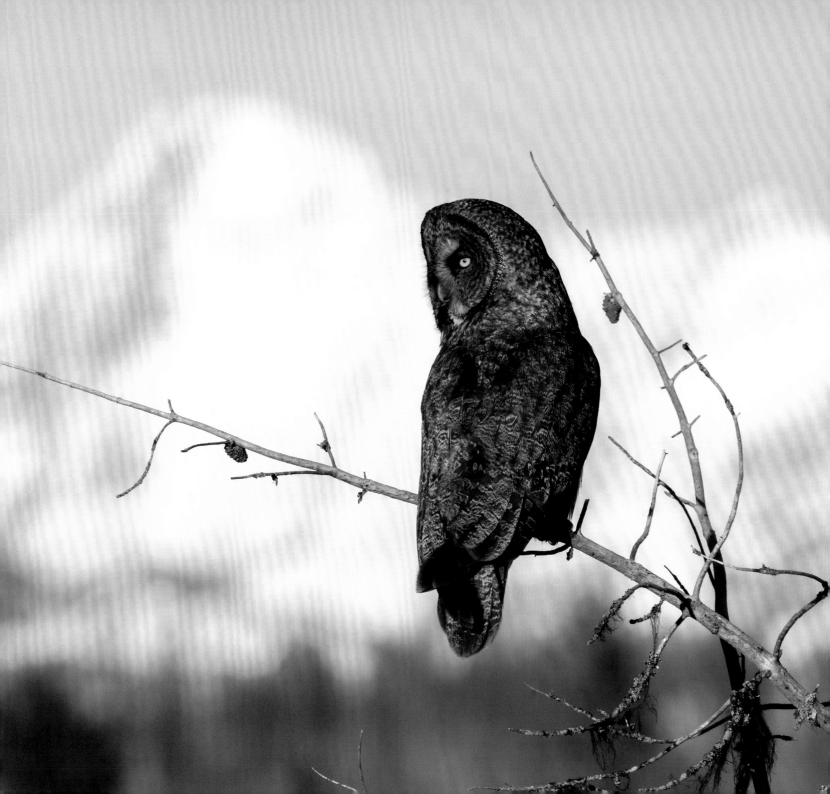

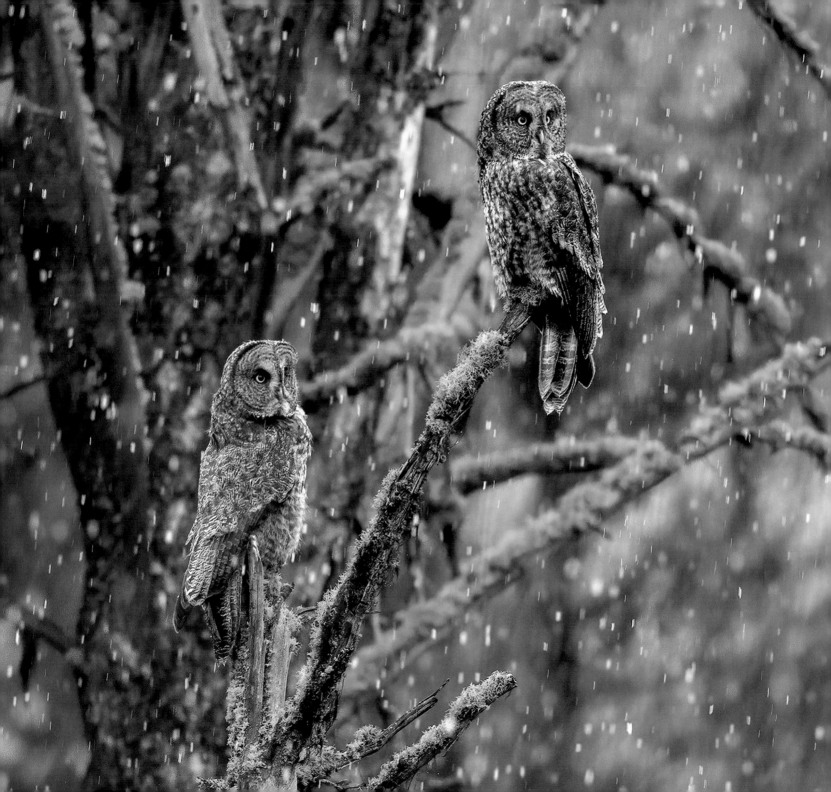

*Juvenile Great Gray Owls often stay together for weeks after their parents have ceased feeding them but usually disperse by the time snow covers the ground.*

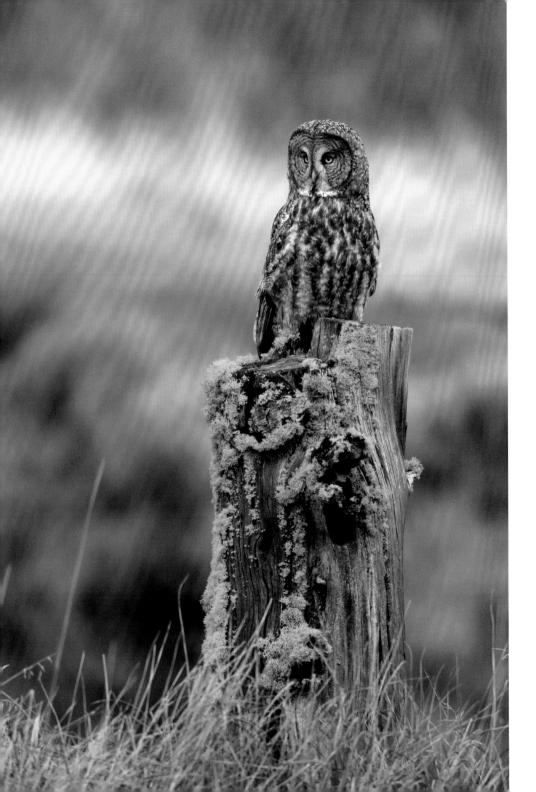

LEFT: *Within their mature forest habitats, Great Gray Owls require large areas of grassy or otherwise unobstructed ground, but they have difficulty hunting without low perches such as snags, stumps, or low trees from which to listen for prey.*

OPPOSITE: *Great Gray Owls use snags or standing dead trees for nesting, roosting, hunting, and, as with this male, unobstructed resting perches when returning to the nest with prey.*

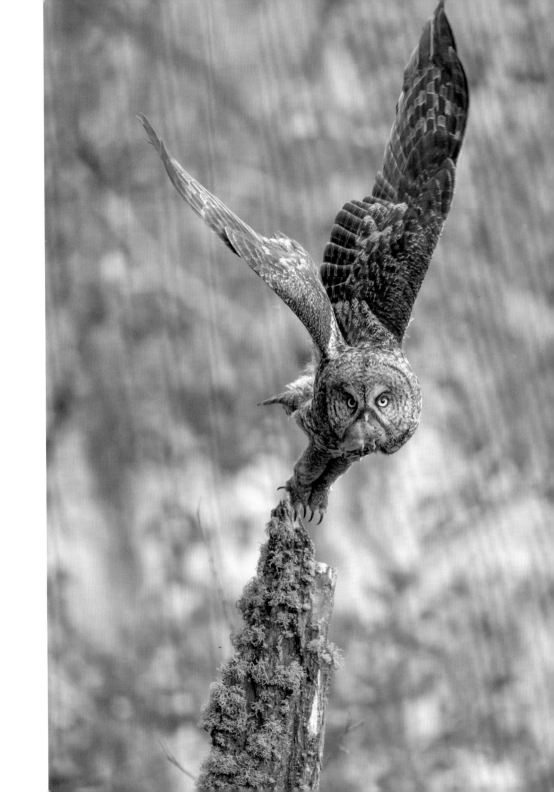

# BREEDING

The Great Gray Owl's ability to capture a large number of voles or pocket gophers is essential to its breeding success. When voles and gophers are easier to catch, Great Grays breed earlier, in higher numbers and with a greater concentration of nests, and produce more young. Breeding is therefore influenced mostly by prey population cycles throughout the owls' range and by snow depth in the high-elevation and high-precipitation western mountains. During years of heavy snowfall, breeding can be delayed by up to six weeks. When prey is scarce, Great Grays may skip breeding altogether.

Outside the breeding season, a Great Gray Owl's home range can sprawl across several dozen square miles, but during courtship and nesting, it contracts as the male focuses on hunting closer to the nest. Studies in Oregon showed adult home ranges averaged forty-one square miles during the winter and less than three square miles during the nesting season. Great Grays are much less territorial than other North American owls and tend to defend only the immediate area around the nest. The size of the defended territory is dependent on the food supply. During vole "boom years" Great Gray pairs may nest within five hundred yards of each other.

## Nests

The availability of nest sites limits Great Gray Owl populations, but fortunately the owls are flexible about the types of structure they will inhabit. They prefer a flat platform high in a tree and show a preference for sites with overhead cover, likely both to deter nest predation by other raptors or ravens and to provide protection from weather.

Across much of its North American range, Great Grays most often choose large, abandoned stick nests of ravens and raptors, especially Northern Goshawks.

*A male Great Gray Owl arrives at a nest snag to deliver prey to his mate to feed their young.*

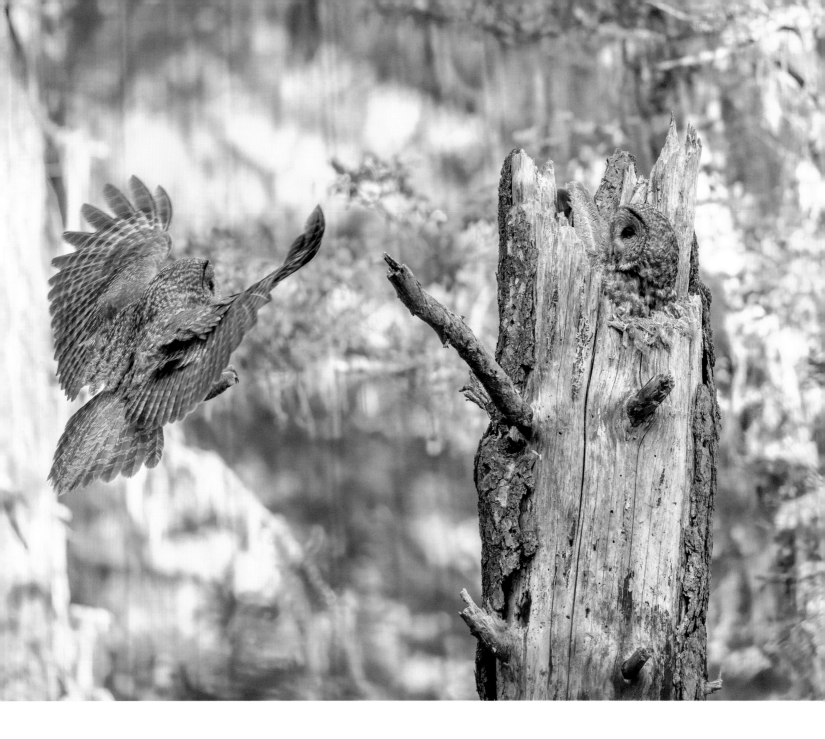

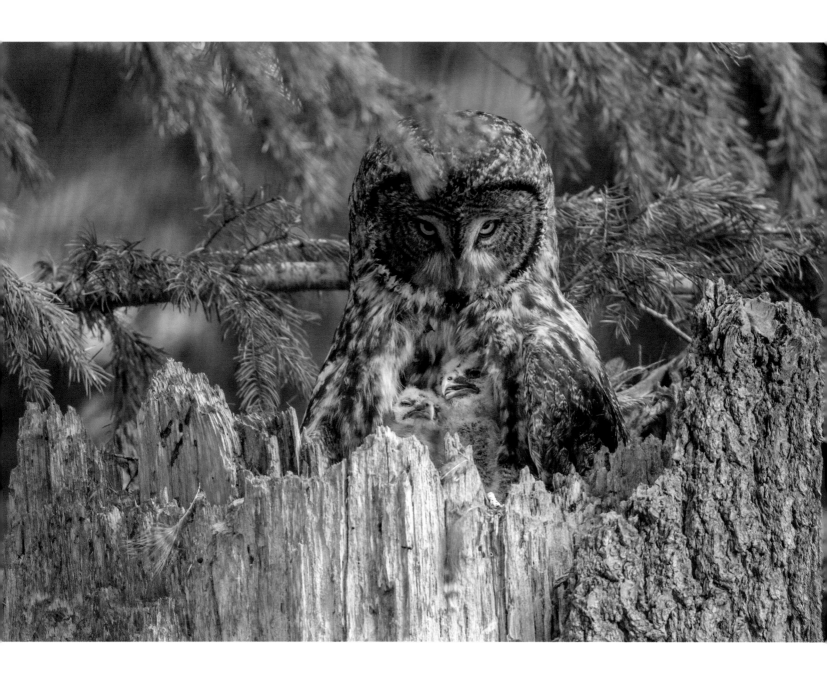

Witches' broom, a dense mat of branches formed in response to an infection or infestation, such as from dwarf mistletoe, is a secondary nest option in most places. Moving south in their range, where the trees grow faster and larger, Great Grays show a preference for the rotted, broken tops of trees or snags, which are often more stable than stick or broom nests and which the Yosemite subspecies utilizes almost exclusively. The surface of a Great Gray nest needs to be stable enough to support the eggs and young and porous enough to allow water to drain but not so porous that the nest falls apart. Ideally, there is a lip or an edge that hides the brooding female and young birds. Whatever the platform, the Great Gray scratches and scrapes a depression for the eggs at the bottom of the nest, which may hasten the nest's demise but helps the owl determine how viable the nest will be.

A Great Gray sometimes utilizes a nest in consecutive years, but more often it alternates between nest sites within its home range. They will readily use artificial platforms, suggesting that natural platforms are often in short supply.

## Courtship and Mating

Great Grays retain the same mates from year to year in the western mountains of North America, where they do not migrate or irrupt and remain in relatively close proximity to one another. Boreal populations of Great Gray Owls do not normally keep the same mate over the winter but in some years they may do so if they do not migrate and prey populations are high.

Courtship begins during the winter under cover of night with the male's low calls inviting the female to consider mating with him. The male often offers his prospective mate a vole to make his invitation more compelling. If interested, the female flies to the male, accepts his offering, and copulates with him.

I will never forget witnessing this ritual one moonlit night deep in an Oregon forest. Two Great Grays had been calling back and forth to each other while flying between fifty-foot-tall snags. The female settled her ample feathers into the recessed top of one of the snags shortly before the male arrived with a vole and

*Two approximately ten-day-old nestlings lean into the downy feathers of their mother's breast to keep warm atop an old forty-five-foot-tall white fir snag.*

*The Great Gray Owl captures prey with its sharp talons but carries it in its bill during flight. Here, a male flies up to his nest to deliver prey to his mate.*

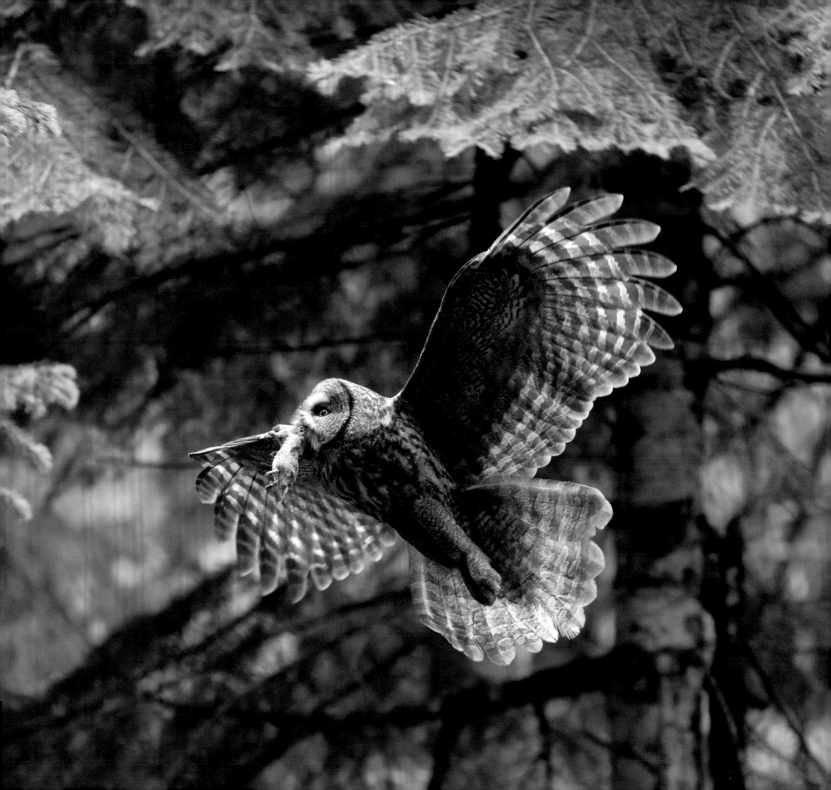

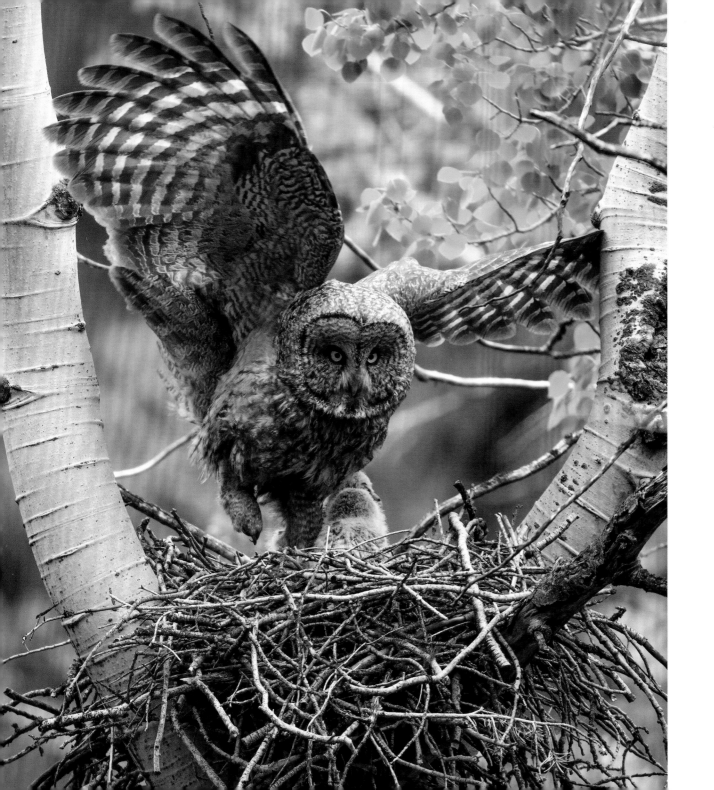

perched on a lip of bark at the edge of the cavity. The pair leaned toward each other, wings spread and eyes closed, chittering, as the male passed a hefty vole from his bill to the female's. After the female consumed the vole, the two mated and disappeared together into the inky distance.

## Nesting

After a Great Gray pair has mated and a nest has been chosen, both owls spend the majority of their time near the nest, with the male delivering prey to the female at night and in the early morning. Between late March and early May, when snow is usually still on the ground, the female settles into the nest, lays her eggs, and spends the vast majority of her time over the next several weeks brooding her eggs and young.

The female normally lays two or three dull-white eggs when prey is abundant, although just one is not uncommon and nests with five eggs have also been reported. Typically, eggs are laid every one to three days, with the female incubating immediately after laying her first. The eggs hatch in twenty-eight to thirty-six days, with thirty to thirty-one days being the average, in the order in which they were laid, resulting in young of different sizes in the nest.

## Nestlings and Fledglings

*After seeing her mate arriving with food, a female leaves the nest to receive it at a nearby delivery perch.*

The Great Gray male feeds the female from the onset of courtship until the nestlings are able to thermoregulate (maintain a steady body temperature) at about two to three weeks of age. Until this time the female leaves the nest only for brief periods to defecate and regurgitate pellets, which are balls of unprocessed fur and bones from prey. The female eats the eggshells and later the young nestlings' feces until about a week before they leave. Her subsequent disposal of waste material far from the nest suggests that she does this to reduce odors or debris that might otherwise attract the attention of predators during this vulnerable period.

On two occasions I observed black bears attempt to approach an active nest tree, and I have seen the claw marks of lynx at the base of one. Surely martens, fishers, bobcats, and weasels are attracted to the scents and sounds of a nest, too, but it is unclear if they could be successful against an aggressive and attentive female. Great Horned Owls are normally the greatest threat to both adult and young Great Gray Owls, and ravens are a threat to eggs and nestlings. On three occasions I witnessed Northern Goshawks, a formidable predator of other birds, nest within a hundred yards of a Great Gray nest. I never saw the Goshawks approach the Great Gray nest, although I did see them pursue fledglings before being driven away by a parent.

The male captures the vast majority of the family's food. In a typical North American nest he may deliver food several times throughout each day and night, most often between dusk and dawn. As the young hatch and grow, the male delivers food more often. As long as the young are in the nest, the male consumes most of the small prey he captures and delivers the rest directly to the female, who in turn feeds herself and the young. When the young are small, the female tears up the prey for them, but after the nestlings are a couple of weeks old, she feeds them most prey whole. At first, the male delivers prey to the female at the nest, but once the young can keep themselves warm, the male gives the female their food at one of a few delivery perches located several dozen feet from the nest. The male does not feed the young directly until after they leave the nest.

When the nestlings are three weeks old, the female begins roosting outside the nest, although she will return to protect the young from heavy rain, snow, or potential predators. She sometimes hunts opportunistically near the nest at this time, but the male retains most of this responsibility.

The young usually leave the nest under the cover of night after twenty-six to thirty days, although they are still unable to fly, unlike fledglings of many other species. The nestlings normally leave over several days, with the largest departing first. I witnessed a group of three leave within fifteen minutes of one another and watched another sibling group of three disperse over four days. The young owls may jump from the nest to the ground, but more often they climb onto adjacent

*Just before leaving the nest, the young frequently flap their wings as they cling to the outer edges of whatever structure forms its confines. In this case, the female flew to the nest and blocked the path of her nestling who had moved toward an outer branch and pushed it back into the nest.*

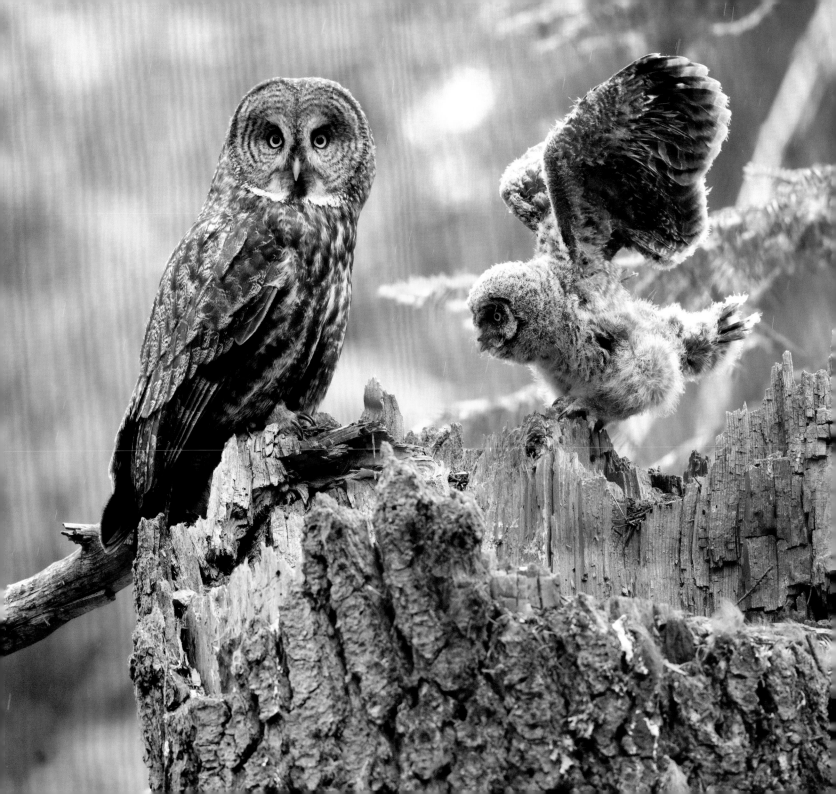

limbs or trunks before jumping, falling, or being knocked to the ground by the errant wing of a sibling. One spring in Alberta I was watching Great Gray nestlings exercise their wings when a strong gust surprised one youngster and somersaulted the flapping fluff of feathers some fifty feet away from the nest and onto the ground.

Once on the ground, the young quickly waddle toward leaning trees and snags, making their way up them surprisingly quickly using bills, talons, and even wings as climbing aids. As they get larger and stronger, they climb and roost progressively higher in the trees, often attaining heights of forty feet or higher before they are capable of self-powered flight. Only after they are confident in their flying do they begin to roost lower.

The Great Gray female continues to help protect the young for about three to six weeks after they leave the nest. After that period, she leaves them, sometimes visiting other Great Gray parents and young. Occasionally she returns to the vicinity of her family group but does not engage in the care or feeding of her offspring. The male continues to look after the fledglings until they are able to hunt on their own, which occurs about three months after they leave the nest. Some research has shown that in contrast to many raptors, Great Gray Owls sometimes provide more food and care to small, weak, or injured young in an effort to help them catch up to their stronger siblings. Approximately 40 percent of Great Gray young fail to reach the fledgling stage, and about 50 percent fail to survive their first year.

Most owls are highly territorial toward others of their species near their nests, young, and hunting sites, but the Great Gray Owl is an exception. While caring for their own young, males have been known to feed and even care for orphaned fledglings. I have also seen males share hunting fields while provisioning their young. This isn't to say that Great Gray Owls aren't fiercely protective of their nests and young. They are indeed and have injured people who get too close. One researcher reported that being hit by a Great Gray felt like being hit by "a two-by-four with nails." I was aware of the owl's reputation before I began looking for Great Grays and thus never pushed my luck enough to risk such attacks. I normally approach

*In a threat posture that is typical for all owls, flightless and vulnerable juvenile Great Gray Owls clack their bills, spread their wings and tails, and fluff their feathers to appear larger and threaten would-be predators.*

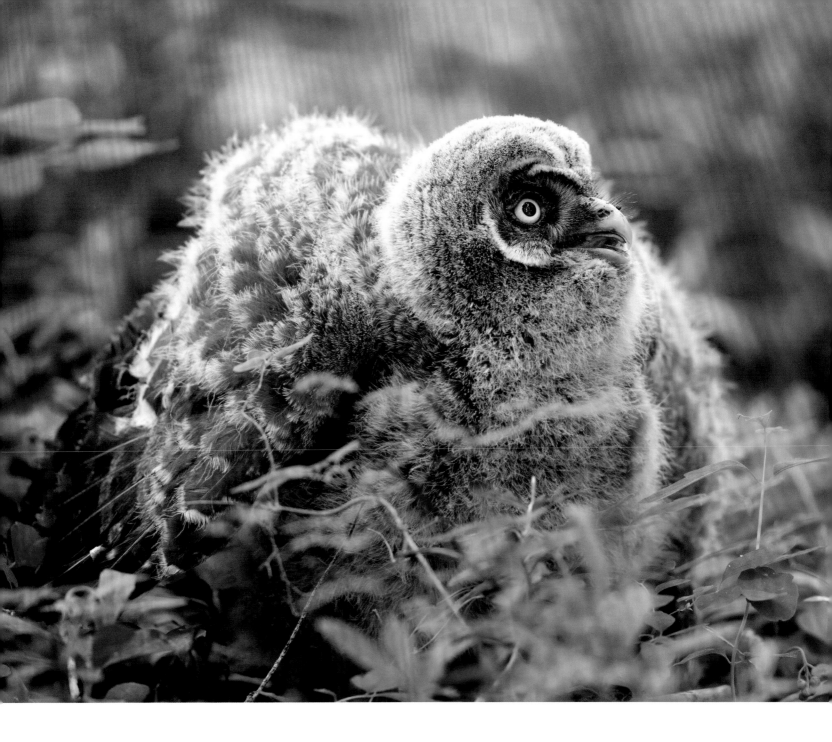

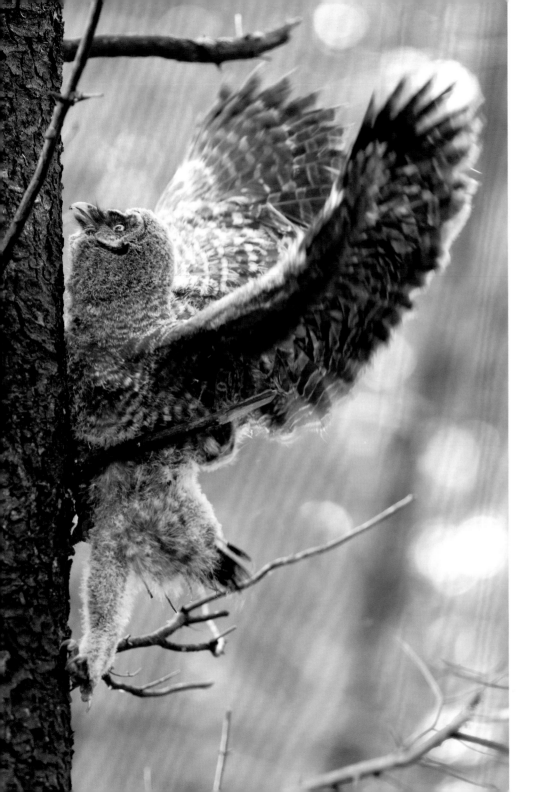

nests or young in an indirect way that allows the birds to feel safe, and I always try to photograph with a 600mm lens and extenders and from within a blind whenever possible. Great Gray Owls give warning hoots when people are too close to their nests, and I am grateful never to have warranted a physical attack.

On three occasions—in British Columbia, Washington, and Idaho—I have watched as young Great Gray Owls transitioned to independence. Finding each of these families was a thrill, as I had the opportunity to witness the owls at a critical inflection point in their lives. My experience in Idaho was especially memorable.

I was observing an adult Great Gray male with two fledglings in fall, a time of rapid seasonal transition in the mountains of central Idaho. The increasingly golden leaves of cottonwoods painted a path along the rivers, and afternoon temperatures fell quickly as the sun dropped behind the peaks. Every pond, tree, and blade of grass was glazed a prickly white before the rising sun attempted to push back winter's breath each morning.

The three owls I was watching were changing their behavior in response to the season. Normally, morning would find the owls retreating to their roosts after their pre-dawn hunt, but the frozen ground left voles inaccessible, forcing the adult to hunt into the day to provide enough food for the young. A sharp *eeesshk* from behind me signaled the presence of a begging young owl. It had to be close by, but I could not see it until it screeched again and the rising and falling of the owl's body helped me distinguish it from the gray bark of a large fir. The male darted in quickly and, without slowing his flight, touched a foot on the stub of a branch, let the youngster tear a vole from his bill, and then flew away. The young owl dispatched the rodent in two gulps. The entire exercise was completed in a few seconds. I could not help but wonder how many times I might have missed such fascinating behavior as I was looking at the last image on my camera's LCD or putting on my gloves. Within an hour the awkward gray youngster, looking very much like a scruffy adult sans bow tie, began begging again, and as I focused my camera, I was surprised to see an equally awkward second juvenile fly into the frame and beg alongside its sibling.

*As soon as they leave the nest and until they are capable of controlled flight—a process that takes several weeks—juveniles instinctively attempt to get as high as they can to avoid predators. This makes leaning trees and snags critical to their survival as it is extremely difficult for them to climb straight trees.*

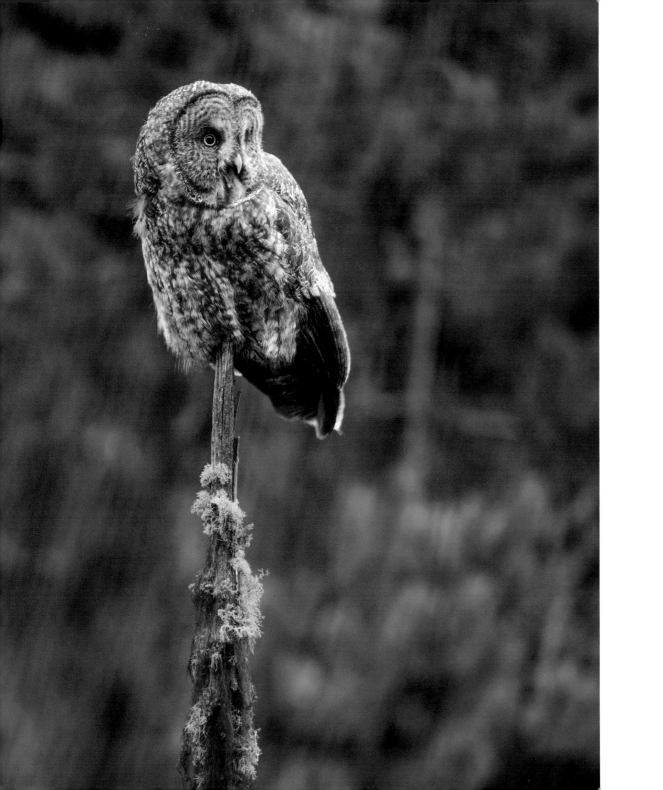

*A juvenile Great Gray Owl begs to be fed as it follows its father through the forest. Just before their late summer or early fall dispersal, juveniles look very much like their parents except for the less defined white markings on their faces.*

Each subsequent evening more snow fell, and the weakening sun became less effective at melting the accumulation. With each silvery morning it took me longer to find the owls, until finally the juveniles' begging betrayed their location. As the days passed, the young owls spent less time begging and more time catching their own food. Still, when one fledgling begged, it was often joined by the other, presumably afraid to miss a free meal. After three days, the parent no longer supplied food for the young and made no more appearances. At the end of most days, the juveniles found each other and slept together on the same high limb of a sheltered lodgepole pine. Five days after the adult male disappeared and immediately after a snowstorm, the owls seemed to have dispersed from the area.

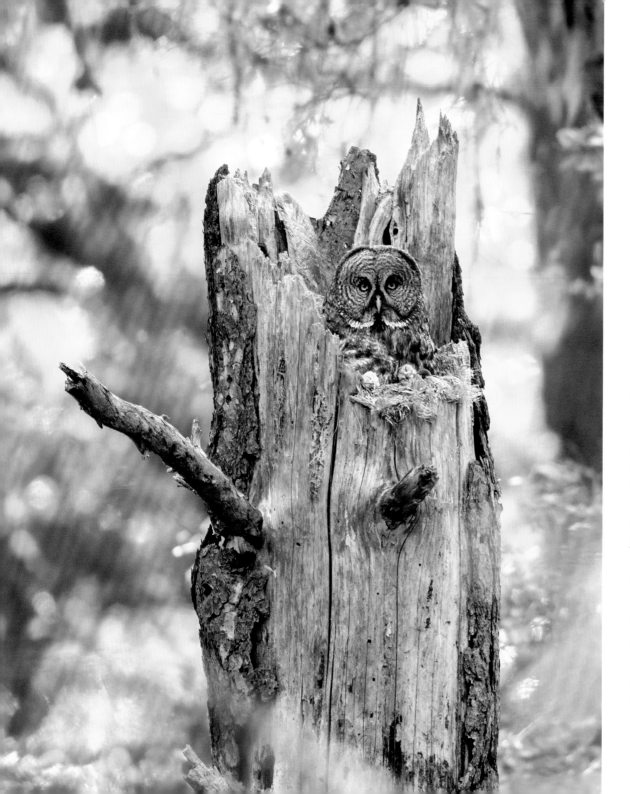

LEFT: *Just a few days old, these two Great Gray Owl nestlings will be dependent upon their mother's warmth for another ten to twelve days, and she will continue to warm them during particularly cold or wet weather for up to three weeks.*

OPPOSITE: *A female Great Gray Owl stares at her nestling before climbing back into her nest after one of her rare breaks.*

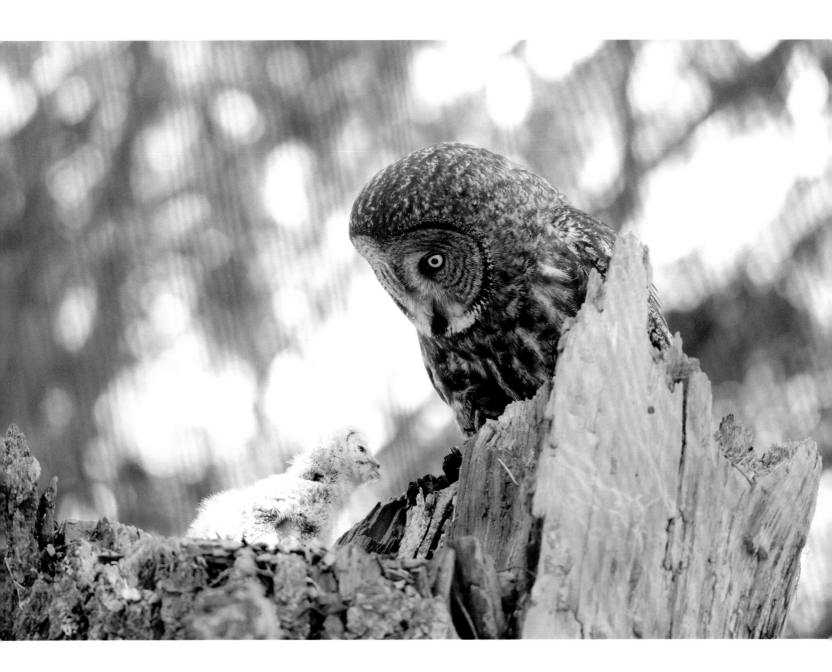

*Fire impacts Great Gray Owl habitat in a variety of ways. Extreme stand-replacing fires can eliminate the forest cover and snags that the owls need for nesting, but less extreme fires burn an irregular mosaic pattern that can create openings for hunting and turn large trees into nest snags. Visible here is a snag with nestlings in a forest that burned before the owls chose this nest site.*

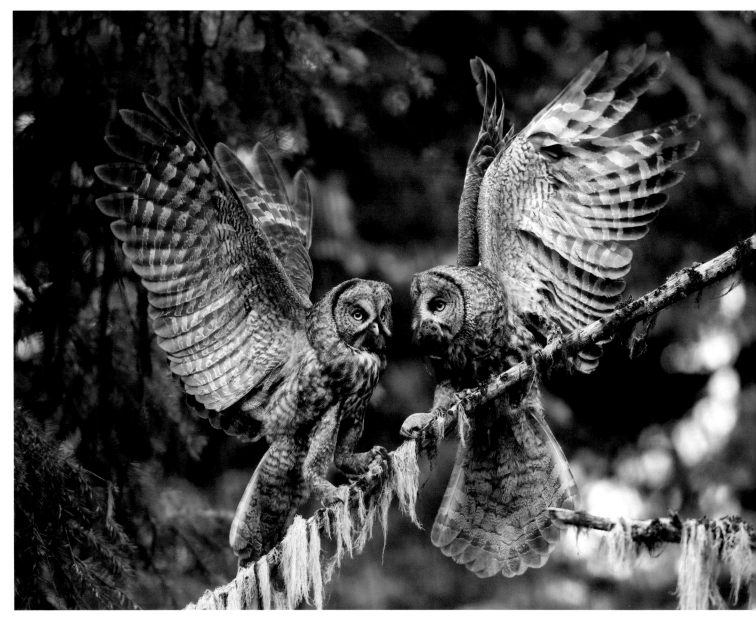

*A female Great Gray Owl (right) accepts prey from her much smaller mate, who doesn't even pause his wingbeats before continuing his hunting.*

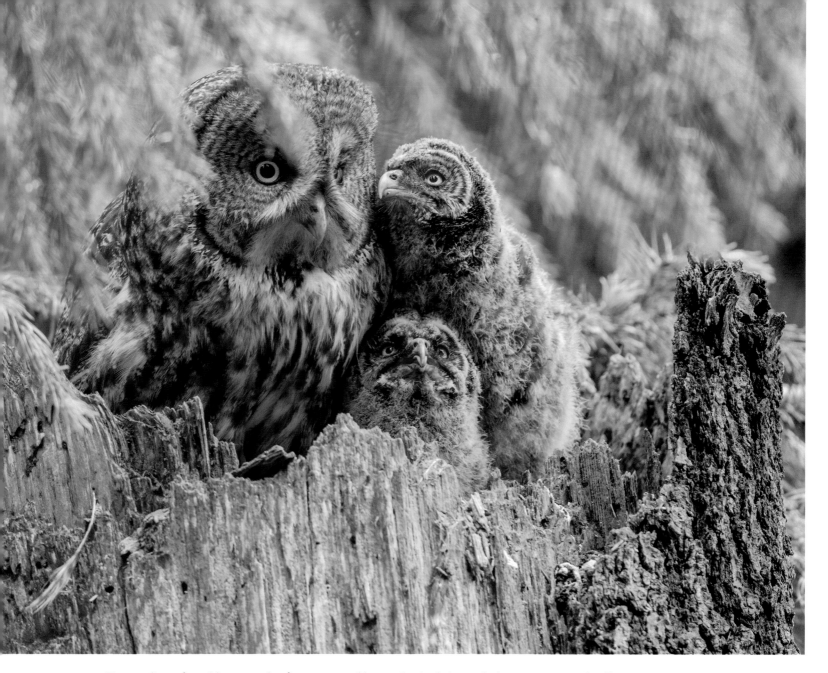

*Two nestlings of roughly two weeks of age are now able to maintain their own body temperature and will no longer need to seek their mother's warmth except during the coldest of days or during rain or snow.*

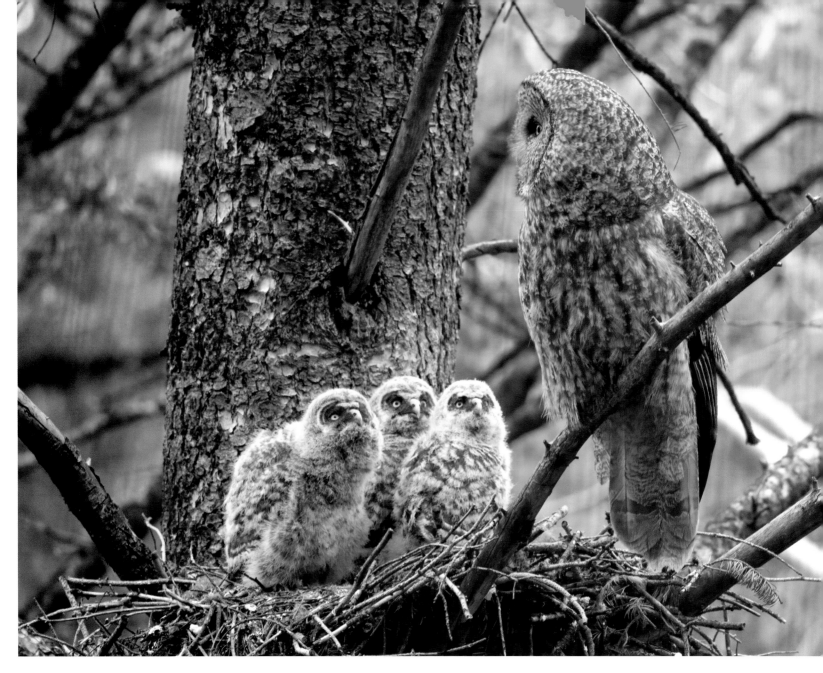

*Three nestlings, approximately four weeks old, look expectantly at their mother as she begs for her mate to deliver food to them at an abandoned Northern Goshawk nest.*

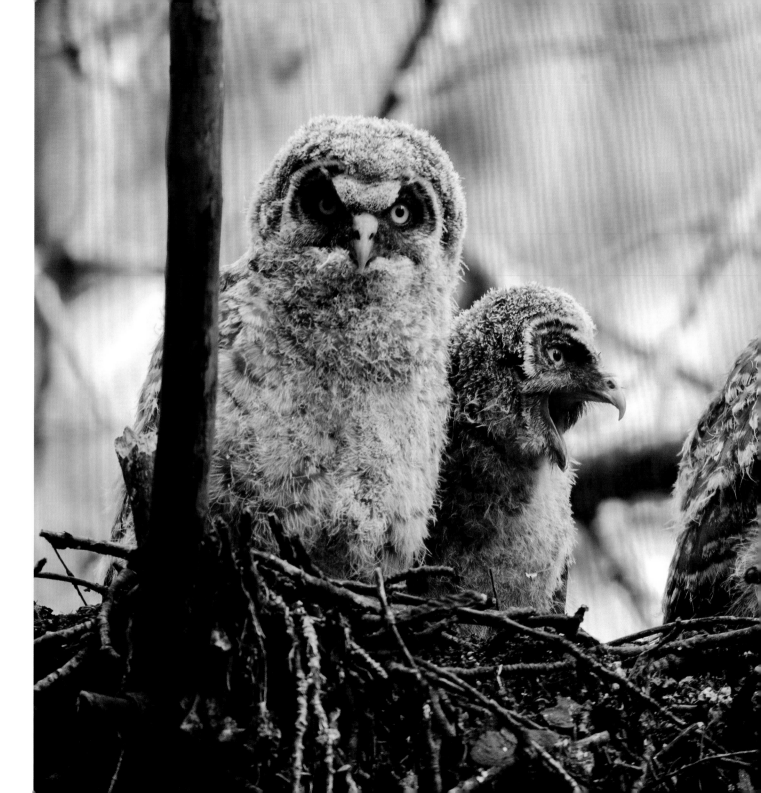

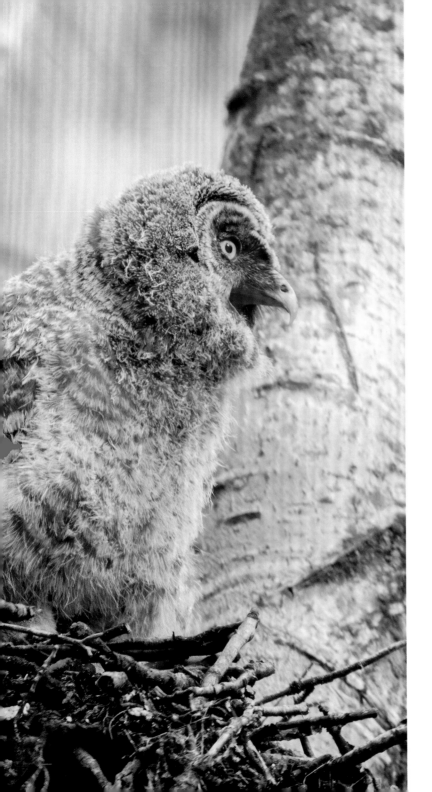

*Two hungry nestlings beg to receive food as the most recently fed nestling sits quietly nearby atop an abandoned Northern Goshawk nest.*

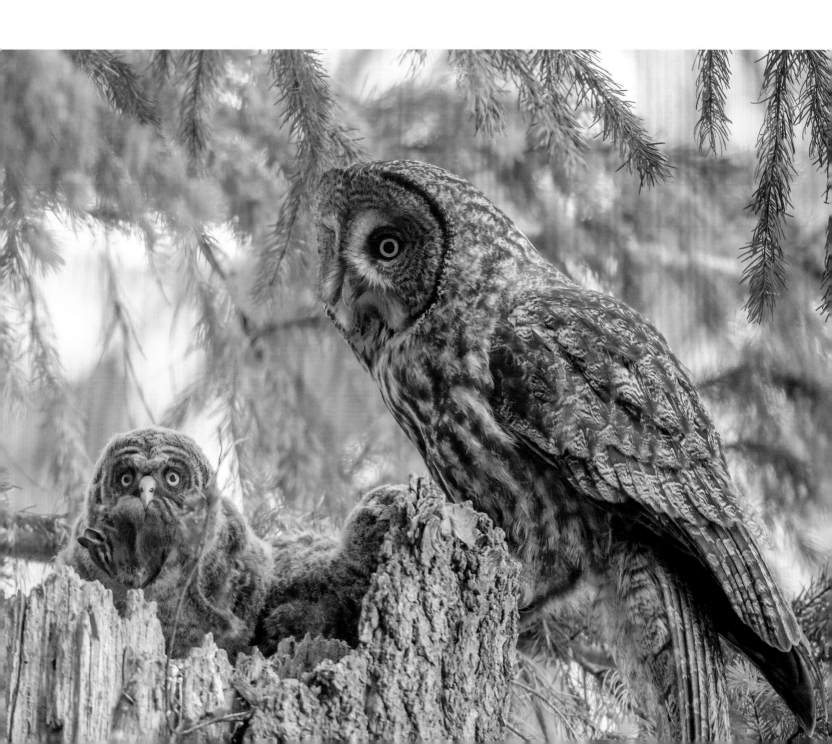

RIGHT: *At three to four weeks of age, young owls begin preparing to leave the nest. During this time they often climb onto the branches surrounding the nest and flap their wings—a behavior known as "branching"—before returning to the nest.*

OPPOSITE: *A nestling attempts to gulp down a chipmunk delivered by its mother. Voles and pocket gophers comprise the vast majority of prey delivered to nestlings. Mothers tear prey into pieces for smaller nestlings, but when they are larger, nestlings will consume each prey item whole.*

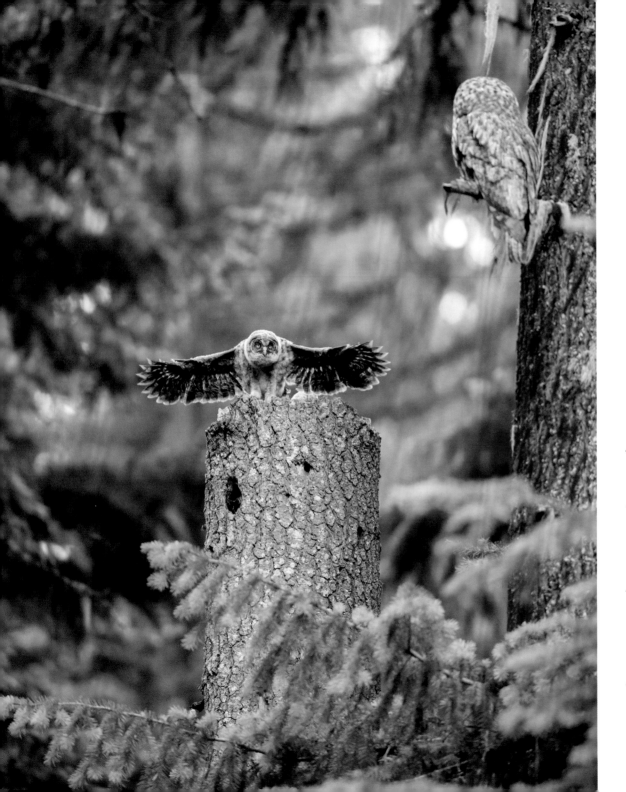

LEFT: *A nestling flaps its wings as its mother looks on. I have witnessed the female flying to the nest to calm young or block them from branching, perhaps steering them toward a better time to leave the nest.*

OPPOSITE: *Frequent flapping helps build flight muscle, endurance, and coordination but the young are still flightless when they leave the nest.*

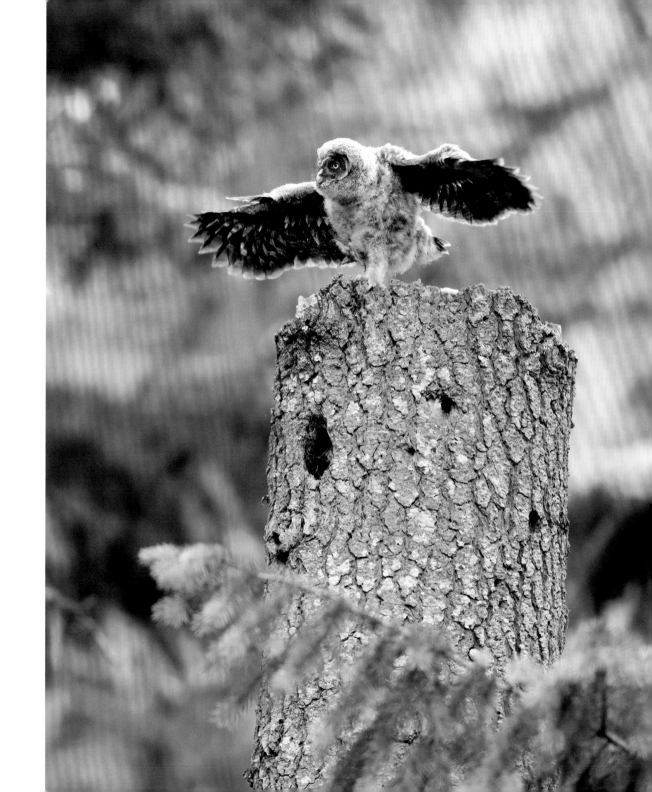

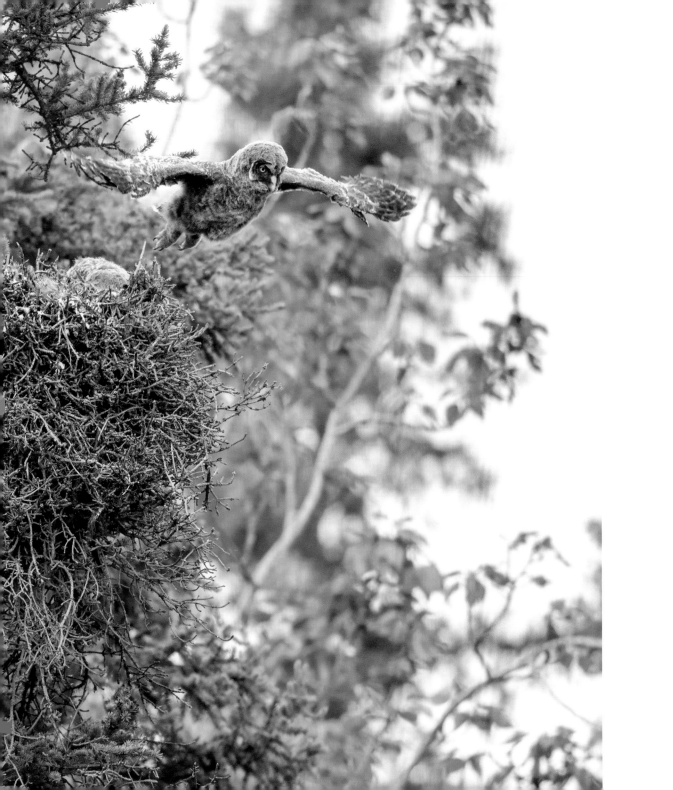

RIGHT: *Hours after leaving their nest, two young Great Grays climb the same tree. Nestling owls often leave the nest over one to three days but eventually roost within a few dozen yards of one another, sometimes even in the same tree.*

OPPOSITE: *As a form of flight practice, young owls flap their wings inside the nest during the last few days before they leave. During this exercise, some young fall, are bumped out, or even intentionally jump, and often attempt to use their wings as they tumble through the air to the ground below.*

*Shortly after landing on the ground, juvenile owls waddle across the forest floor looking for ways to get up higher. Leaning trees and snags are critical at this time in helping these vulnerable flightless owls avoid predators.*

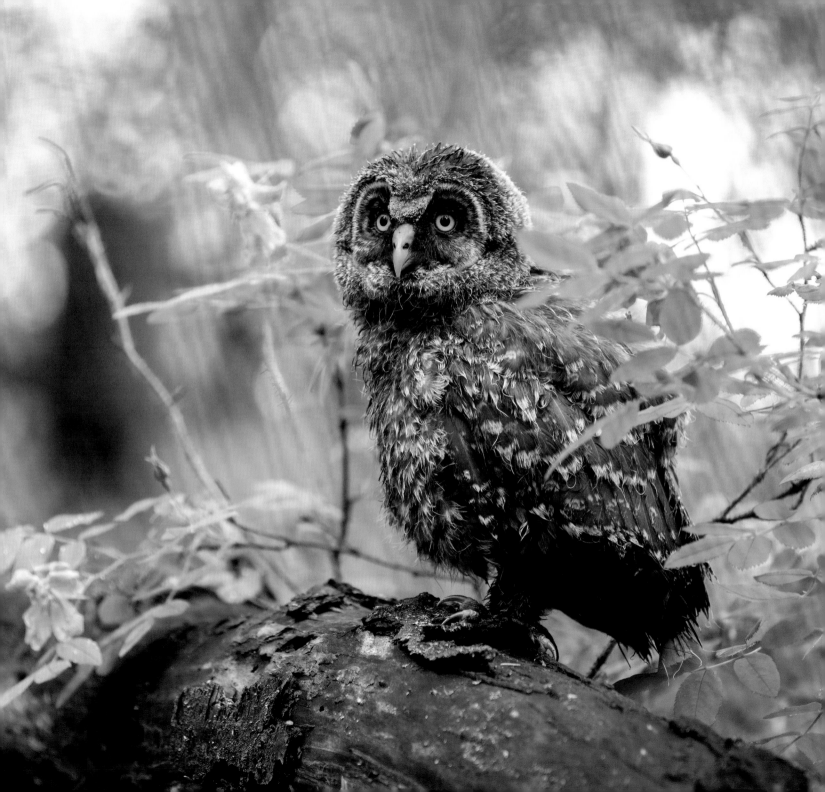

# HUNTING

Great Gray Owls are primarily nocturnal, hunting most often between dusk and dawn. However, they will also hunt in the day, especially during irruptions, when nights are particularly cold, or when they are raising young. At those times they are most active during cloudy, windless, late afternoons and early mornings but will hunt opportunistically at any time of the day.

Great Grays prefer to hunt where prey is most abundant, perches are available, and the ground is free from obstacles that might impede their efforts to capture prey. Large, irregularly shaped forest openings are therefore ideal, but the owls also hunt in open woodlands where the ground is not too obstructed by trees or shrubs.

## Diversity of Prey

An owl's feet provide a strong clue as to what type of prey it targets. A Great Gray Owl's talons are sharp, but the size and spread of its feet are not as generous as those of the Snowy Owl or the Great Horned Owl, so it pursues smaller prey than those owls do. Great Grays swallow most of their prey whole, while larger prey is consumed piece by piece off the carcass.

Great Gray Owls feed primarily on small mammals, mainly meadow voles in most areas and pocket gophers in others. Range-wide, voles make up as much as 80 percent of the owls' diet. In the Cascades, northern Rockies, and Sierra Nevada, pocket gophers comprise the majority of the owls' diet, but the birds alternate between voles and gophers in response to their relative abundance. Supplementing their diet with an alternate prey species when the other is in short supply is one factor that allows Great Gray populations in the southwestern part of their North American range to be more stable.

*Shortly after the young leave the nest, the female departs from the family group and the male must hunt to meet the food needs of himself and the juveniles, which often requires him to forage day and night.*

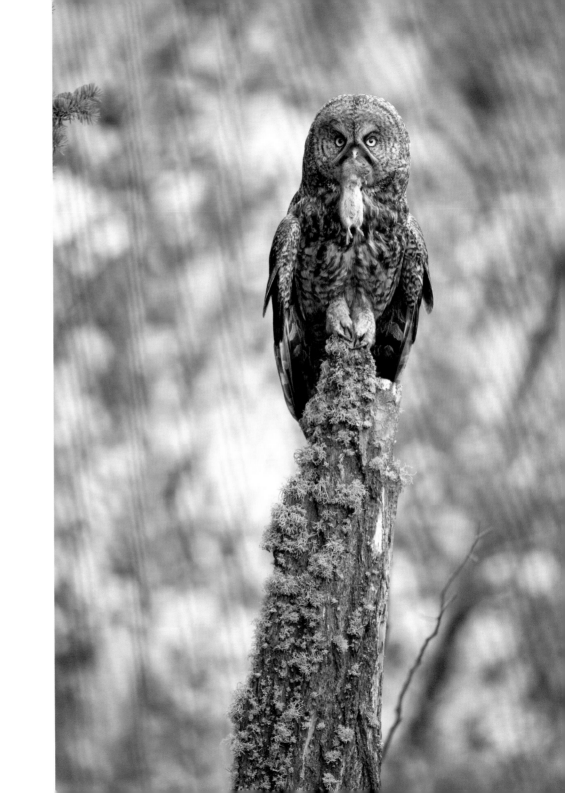

*While Great Grays do most of their hunting in open areas with uncluttered ground, they also will hunt opportunistically in forests, such as among these stunted spruce trees in the boreal.*

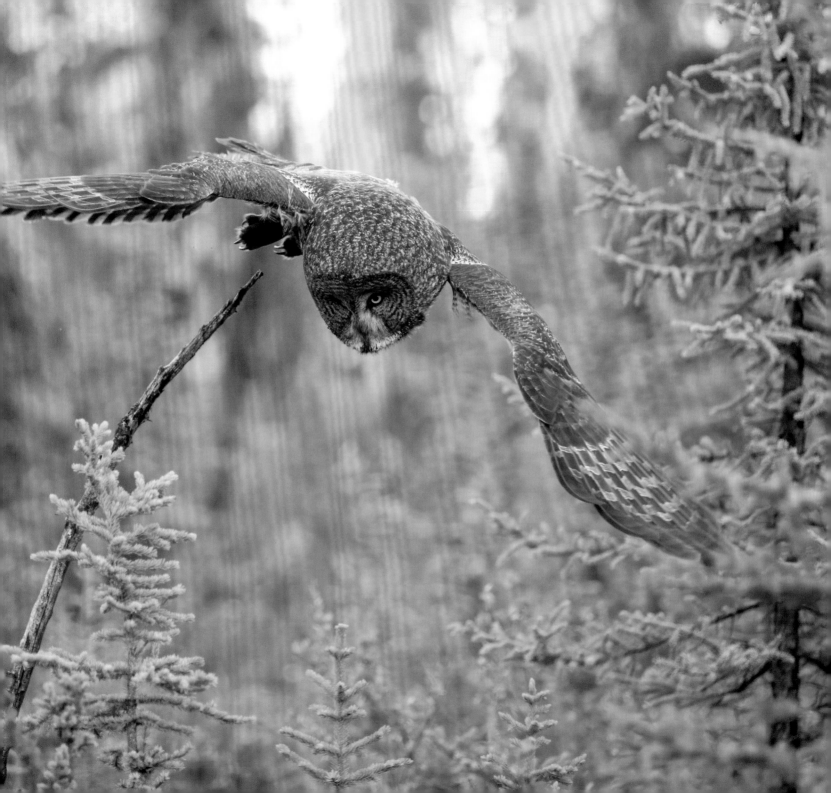

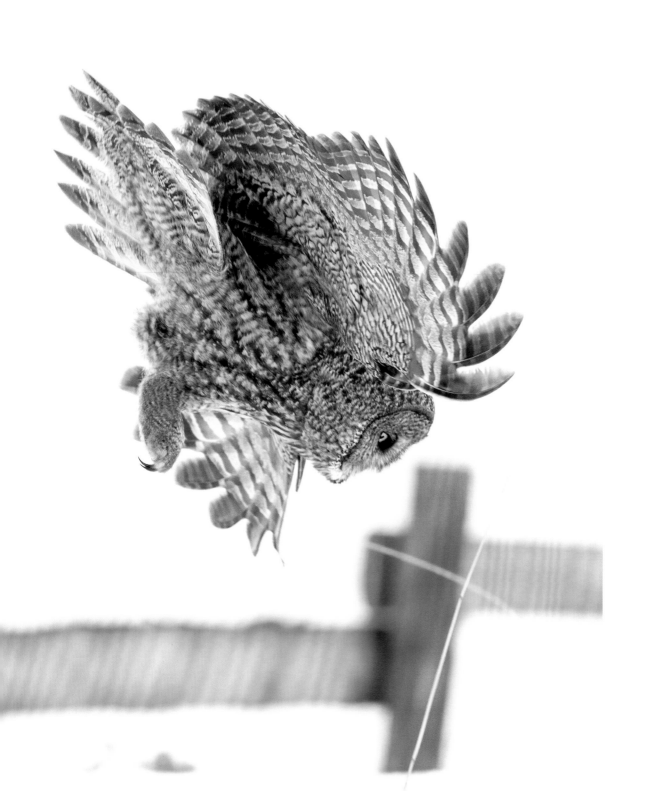

I have seen Great Gray Owls occasionally hunt chipmunks, red squirrels, flying squirrels, and small ground squirrels and have witnessed them delivering to their young the fledgling and nestling birds of other species, star-nosed moles, shrews, and even a red-legged frog. I found many small hare legs below one Great Gray nest but did not actually see an owl deliver them. Evidence of a variety of other prey has been reported, including but not limited to other species of voles, mice, weasels, lemmings, jays, grouse, and even small hawks.

Owls consume more prey when they are more active and during cold weather. A wintering adult Great Gray Owl eats the equivalent of five to seven voles per day, in contrast to a brooding female, who may consume as little as a quarter of that during a twenty-four-hour period. Most of the time the owls eat prey immediately, but during the breeding season they sometimes store excess food at the nest or even cache it in nearby trees.

## Built for Hunting

Great Gray Owls live where snowfall is plentiful and often remains on the ground for more than six months of the year, well into the owls' courtship period, when sharing food is a critical element of breeding success. To meet this challenge, the Great Gray is capable of hearing and capturing unseen prey moving beneath as much as eighteen inches of snow and has been reported to have the ability to break through snow and ice that could support the weight of a 180-pound person. This same ability enables the owl to punch through turf to seize unsuspecting voles and gophers.

The Great Gray owes its exceptional hearing to one of its most distinguishing features: a well-defined disk of stiff feathers surrounding its bill and eyes. This facial disk works like a parabolic reflector to concentrate and amplify sound to two slits—ear openings—one on each side of the owl's head. Like many of the most nocturnal owls, the Great Gray's ears are asymmetrical and work in concert with the facial disk to enable the owl to pinpoint the exact vertical and horizontal location of prey.

*Great Gray Owls often appear to break the crust of the snow with their faces but photography stops the action and reveals that they actually rotate their feet forward at the last moment and punch through turf and snow with clenched feet.*

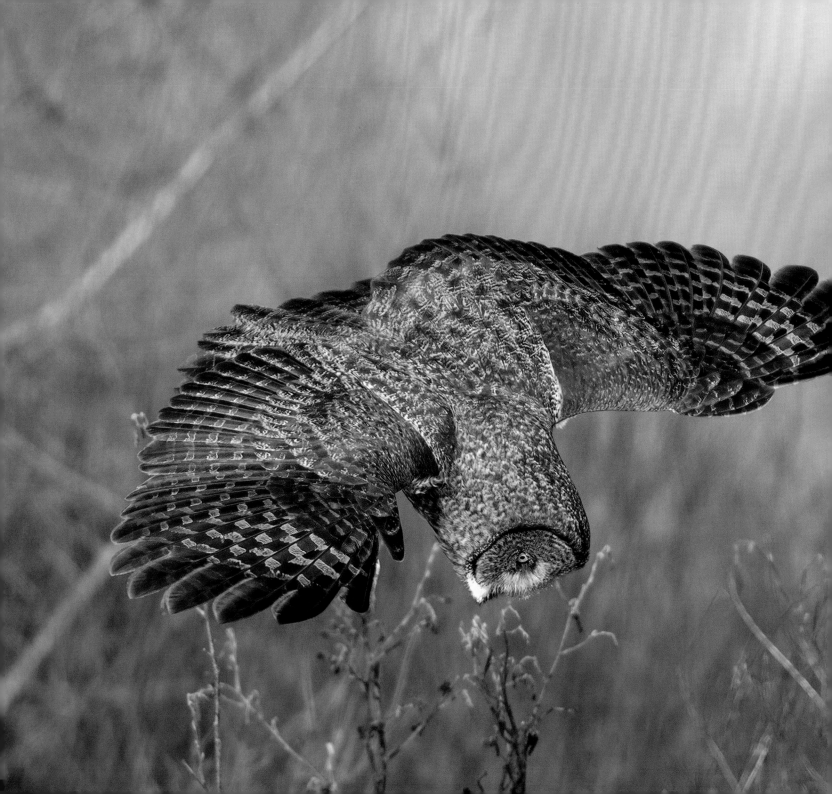

*During a dive, a Great Gray Owl aligns
its face nearly parallel with the ground and
plunges downward. To strike its prey it
will swing its legs and feet forward.*

Along with its impressive hearing, the Great Gray utilizes its vision while hunting and thus has greater success during clear, moonlit nights. Owls are unable to move their eyes, which are actually tube shaped, giving them a narrower field of vision than most birds, humans, and other animals. An owl compensates with a neck structure that gives it the ability to turn its head 270 degrees. As a result, the Great Gray must focus its eyes on the area directly in front of its face and must turn its head to focus on another spot.

Often, a Great Gray will begin to hunt in an area by perching relatively high, where it can use its vision to scan a larger expanse. It may spend several minutes staring in one direction before turning its head to scan a new area. Once it detects prey, it tends to perch close to the ground on a branch, snag, or stump to take advantage of its hearing and will watch and listen to a small patch of ground for anywhere from a few to several dozen minutes. If it fails to locate the target, it turns its head slightly and concentrates on each adjacent area in turn, before giving up and moving on to hunt from another perch. Most successful hunts are initiated from a perch within about 350 feet of captured prey, although the owl also hunts on the wing and will hover where perches are unavailable.

A Great Gray's flight is aided by two characteristics: the large surface area of its wings relative to its body size and the structure of its wing feathers. The ratio of the owl's wing size to body size results in low wing-loading (weight per square inch of wing surface) and enables great buoyancy in flight. Additionally, the fringe-like leading edges of the owl's primary wing feathers, the downy feathers on the wings' surfaces, and the soft fringes on the trailing edges of the flight feathers combine to allow virtually silent flight toward unsuspecting prey.

As the Great Gray Owl approaches its prey in flight, it drops its head below its legs, keeping its facial disk nearly parallel to the ground before swinging its legs and clenched talons forward at the last moment to punch through any turf or snow as it secures its prey.

I have had the privilege of observing the Great Gray's hunting strategies on numerous occasions, including one early summer morning in the Canadian Rockies.

*Listening perches enable Great Gray Owls to spend a lot of time scanning the auditory landscape for prey. Once they take flight, their wing-loading is low enough to allow them to hover over prey, fine-tuning their approach and affording them the best chance of success.*

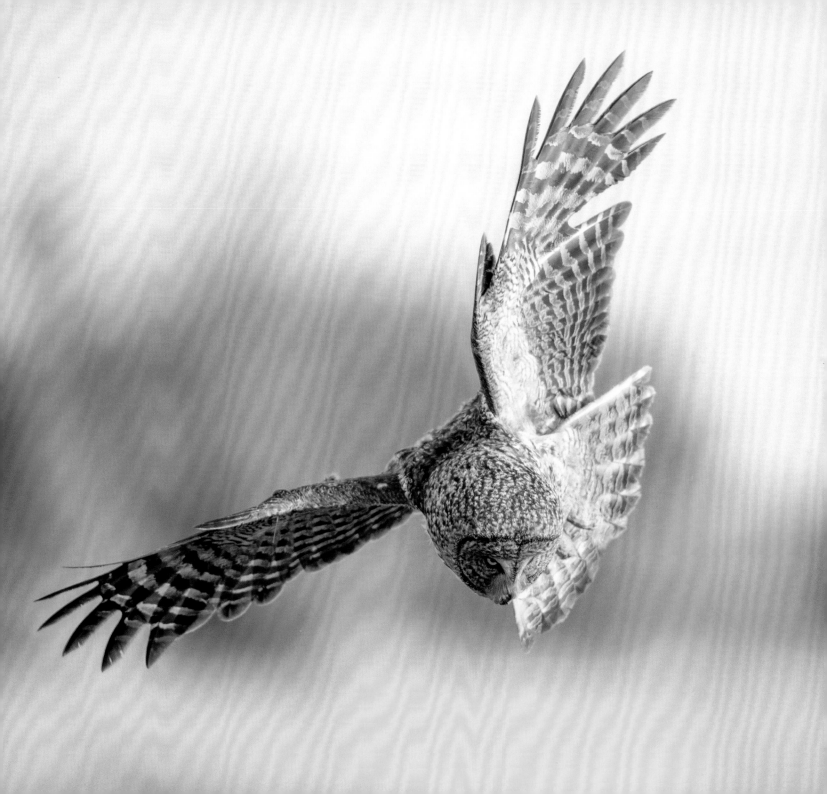

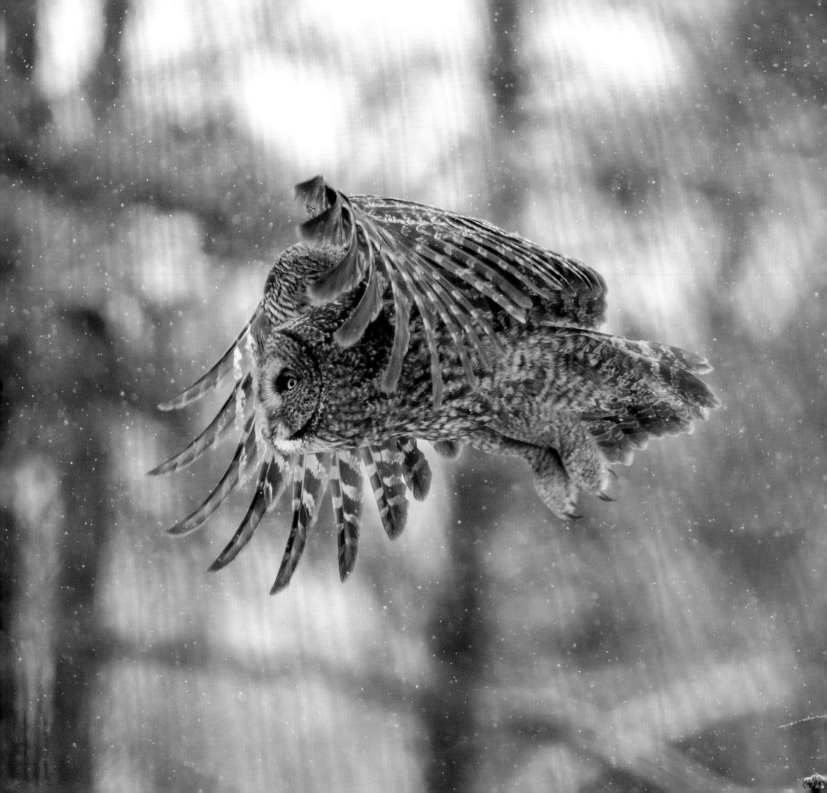

*While they often make silent, subtle launches, Great Gray Owls can move quickly with great force when required.*

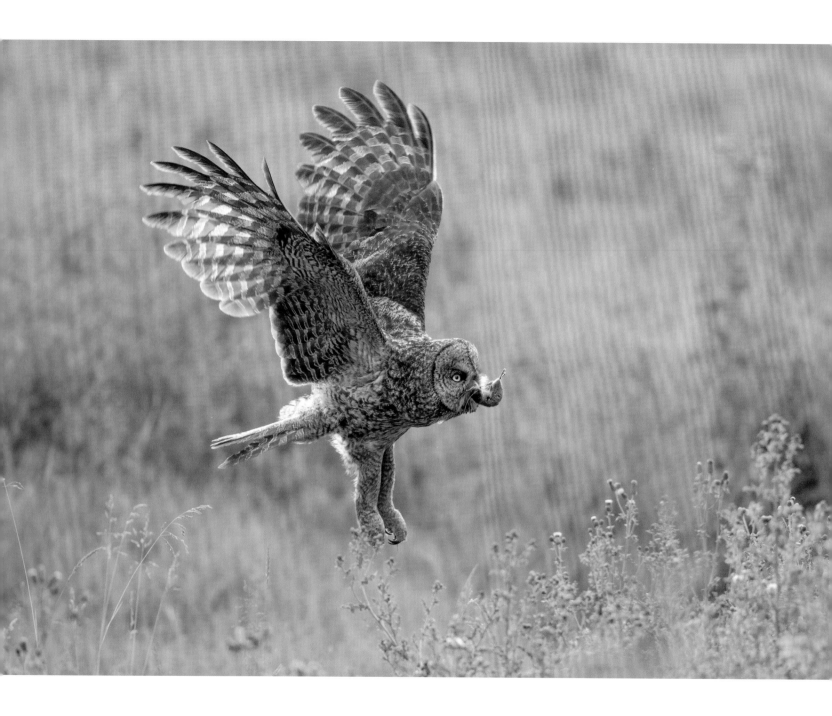

I love looking for Great Gray Owls at dawn, as all of my senses must be alert in order to catch a glimpse of this secretive owl in the dim light. The sound of everything from a broken twig underfoot to a nuthatch scraping its small bill on a tree is amplified, and any movement or shadow is significant. I had not found a nest, but Great Gray Owls lived in the area and I knew that males would be hunting in nearby meadows to feed their mates and young.

The sun was rising as I approached a meadow dominated by blue camas. From a distance, the blue shimmer of the flowers made me think, at first, that I was seeing a lake, but I quickly abandoned that illusion when I realized I was walking toward a grizzly bear. I scuffed my feet in the gravel on the hiking path and shouted, which fortunately scared the bear but unfortunately resulted in it running toward the same meadow I was approaching.

Few things can distract me from a nearby grizzly bear, but a hunting Great Gray is an exception. I sensed a dark shape in my peripheral vision and turned my head to see a Great Gray floating out of the nearby lodgepole pines, hovering over the meadow's wildflowers, then disappearing into them. At this point I had to decide whether to make noise to alert the grizzly to my presence in the tall grass or to keep quiet yet alert so as to not scare off the owl. I chose the latter and remained keenly aware of every scent, sight, and sound. The Great Gray emerged from the grass without any prey and flew slowly over the meadow before landing on a lodgepole sapling so short that the owl's tail almost touched the ground.

After looking and listening in all directions, the owl took flight once more and hovered over a part of the meadow that was without a perch, hanging in the breeze and then spiraling down toward the grass, its facial disk increasingly parallel to the ground, before pivoting its legs forward at the last moment. But, again, the owl missed its prey.

*With their keen hearing and silent flight, Great Gray Owls can capture voles and gophers hidden by tall grass or under turf.*

What followed next was new to me. The Great Gray flew to another perch at the edge of the meadow, and its whole body froze for a few seconds. Then its eyes locked on one place before it flew faster and more directly than I had ever seen a Great Grey fly before and landed hard, feetfirst, on a downed log. After the

squeaking of the prey and the wing flapping of the owl had subsided, the owl disappeared into the woods with a chipmunk for its young. This was the first time I had seen a Great Gray capture prey moving on the surface rather than under snow, grass, or turf.

I witnessed another strategy one winter in northeastern Oregon. A Great Gray was hunting pocket gophers in a rancher's field and would perch on fence posts around the perimeter of the property to watch and listen. It would then fly a curving path just inches above the ground, apparently following the sounds of a gopher moving through a tunnel, and arrive at the tunnel's entrance just in time to capture the emerging rodent. Later, the owl seemed to try to anticipate where a gopher would emerge and would fly ahead to wait at the tunnel hole, although I did not witness any successful captures with this strategy.

*After days of hovering over gophers moving invisibly through underground tunnels, this Great Gray Owl attempted to guess at which opening a pocket gopher might emerge, with mixed results.*

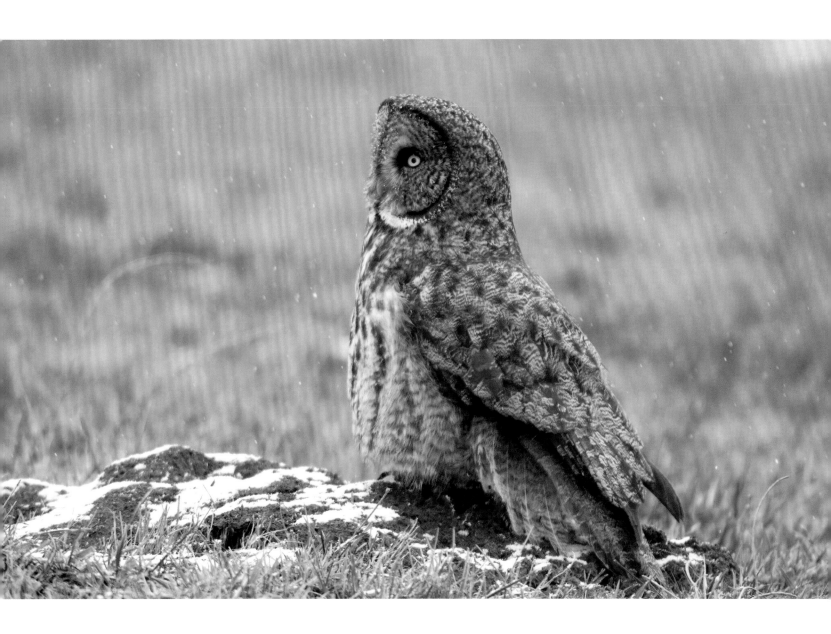

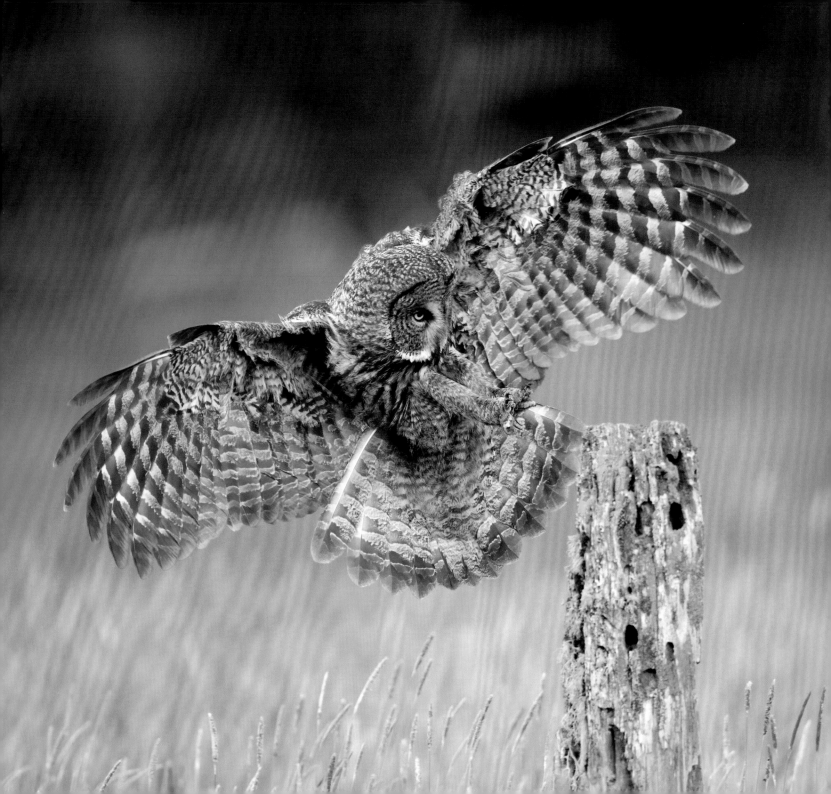

*Undersized feet hint at the relatively
small mammalian prey pursued by this
vole and gopher specialist.*

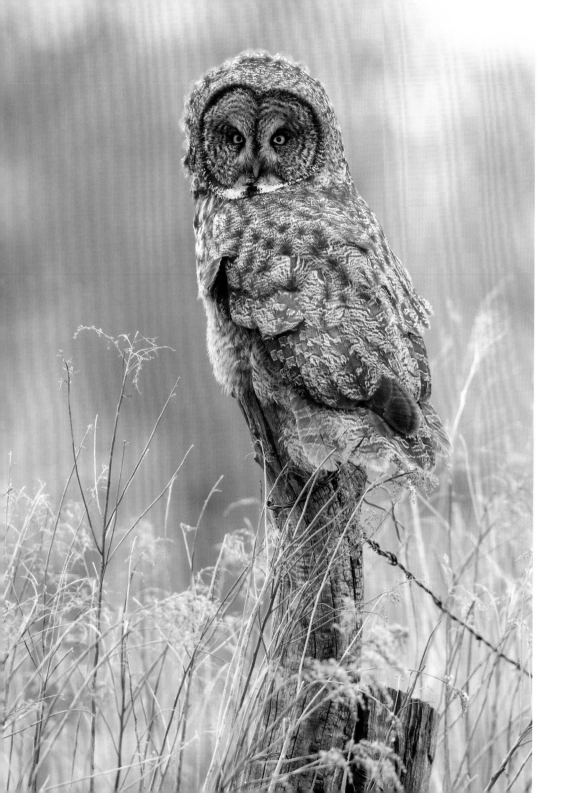

# THE FUTURE

Great Gray Owls are not threatened globally, but across their range their population status varies from vulnerable to imperiled. It is listed as "imperiled" in Washington and Wyoming and "vulnerable" in Idaho, Oregon, and Montana. The Yosemite subspecies is designated as "endangered" and "critically imperiled," with only an estimated 150 birds remaining. California designated the Great Gray Owl as a state endangered species largely based upon the low numbers of the Yosemite subspecies. Partners in Flight, a coalition dedicated to protecting North America's land birds estimated in 2016 that just 95,000 Great Grays remained in North America. Given their small numbers, thin distribution on the landscape, and the large home ranges needed to support them, these owls are vulnerable to local extirpations, particularly at the edges of their distribution.

## Threats to the Great Gray Owl

Anything that disrupts their habitat structure or prey base poses a threat to Great Gray Owls in both their boreal and western mountain habitats. The harvesting of mature trees, climate change, the conversion or development of forests or meadows, resource extraction, and grazing all can alter the critical mix of mature trees and prey-rich forest openings. Encounters with humans can also be an issue, especially where winter irruptions occur.

Timber harvesting poses the greatest threat to Great Grays in all areas since it often removes large trees used by adult owls for nesting, leaning trees needed by flightless young owls for climbing off the ground, and the tree canopy that protects nests and young. This is particularly true in the western mountains where the trees grow faster and taller than in boreal forests. Large trees and snags also fall victim to aggressive thinning, a tactic used in an attempt to reduce the frequency and severity

*With the wind at its back making auditory hunting more challenging, a Great Gray Owl looks for prey from a fence post alongside ranchland in Oregon.*

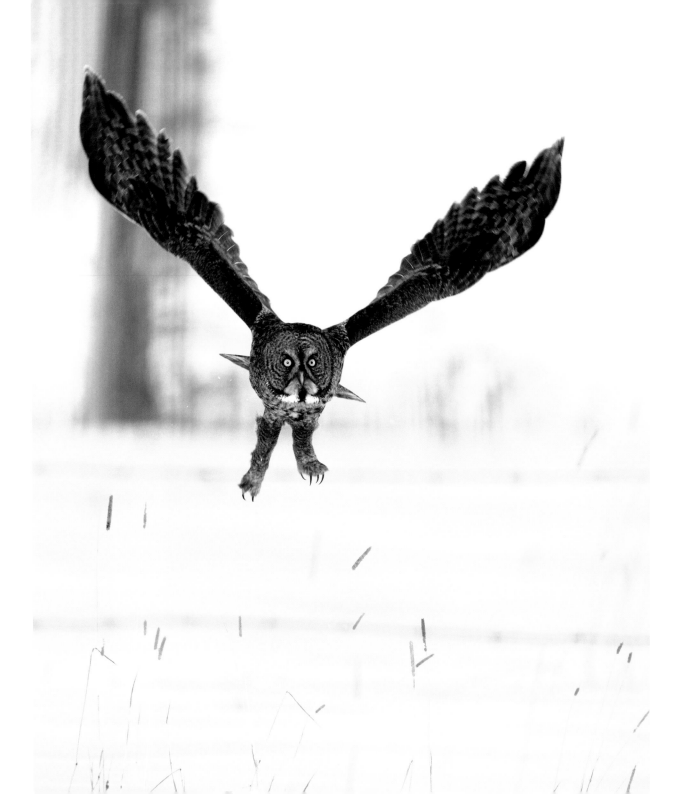

of forest fires in response to economic and personal safety concerns of humans. In boreal forests, which have a short growing season, large conifers grow at 10 percent the rate of those in more temperate regions. Consequently, the Great Gray's boreal habitat is slow to recover after timber harvesting or fire.

We cannot be certain how climate change will impact Great Gray Owls, but it is already affecting habitat by raising the temperature and lowering the moisture in both the boreal forest and western mountain regions, which directly impacts vole populations. Warming temperatures are drying out the trees and understories of forests in both areas, making them more flammable, while at the same time reducing the water content of prime vole habitat. Water lies just beneath the soil in much of the boreal, forming innumerable moist forest openings in the form of lakes, ponds, muskegs, and bogs favored by voles. Patchy permafrost underlies much of this habitat, holding more water at or near the surface. As permafrost melts due to warming temperatures, the water evaporates or sinks into the ground, potentially reducing vole habitat, allowing trees to fill in open areas, and releasing carbon into the atmosphere, further accelerating climate change. And if vole populations decline, Great Gray Owl breeding success will decline as well.

Warming temperatures also allow insect pests, such as bark beetles and mountain pine beetles, to spread to new areas and complete more breeding cycles, exponentially increasing their numbers and leading to the death of huge swaths of forest, which then become flammable fuel for more frequent and catastrophic fires. Although fire has always played a role in both the boreal and the western mountains by creating helpful openings and diverse multi-age forests, these more recent conflagrations decimate much larger areas, which subsequently take much longer to recover.

Tree harvesting and fire also alter forest composition. In the boreal, the long-lived but slow-growing conifers favored by Great Grays are often replaced by deciduous trees that grow more readily on disturbed sites. To make matters potentially worse for boreal Great Grays, the forest industry is investigating disease- and insect-resistant varieties of trees for reforestation that would be less likely to break, become infested with mistletoe, or form dense branch structures in response to `

*Great Gray Owls' long legs are useful for punching through deep snow or turf to capture prey, but when the owls take flight from the ground, their legs often dangle awkwardly until they are moving forward.*

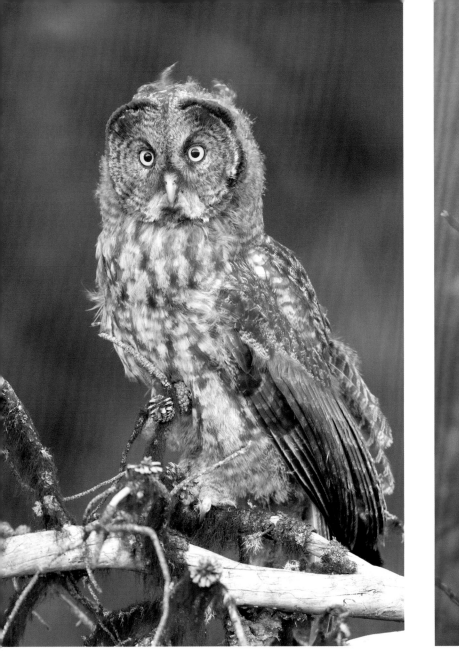

LEFT: *A couple of months after leaving the nest, juveniles are scruffier and thinner-looking versions of the adults with less defined white markings.*

RIGHT: *A juvenile Great Gray Owl anticipates the arrival of its father with prey as a sunset is colored by a distant forest fire. The warming climate and the associated fires are altering forests across the Great Gray Owl's range.*

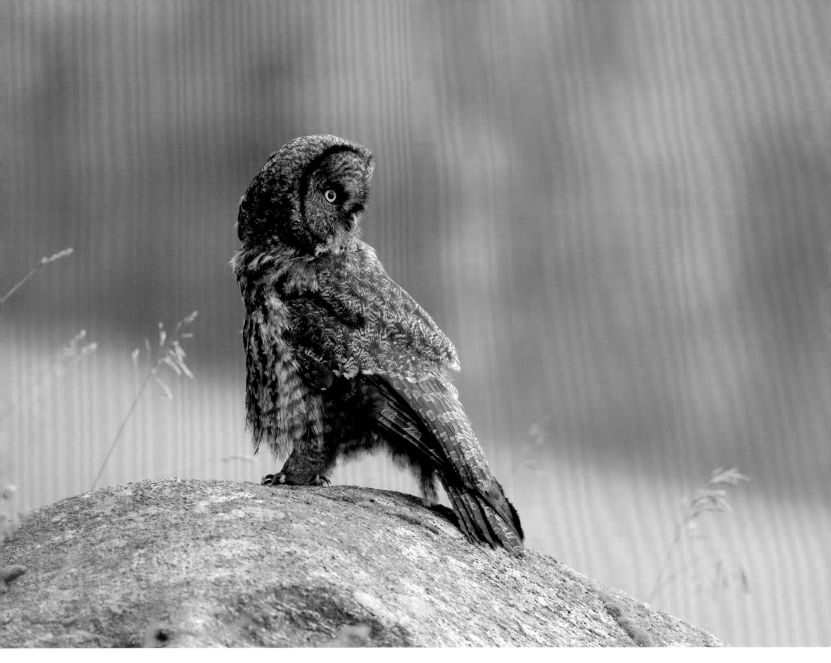

*Using a large boulder as a hunting perch, a juvenile hunts for grasshoppers and voles in the surrounding ranchland. Ranches, agricultural areas, and public lands play an important role in the survival of Great Gray Owls in the southern and western part of their range in particular.*

disease, all of which directly or indirectly provide nest options for Great Grays, especially in this area where trees grow more slowly.

The conversion of forest or treeless land to agricultural land reduces Great Gray Owl habitat throughout the owl's range. Mining, hydropower projects, oil shale exploration, peat harvesting, and extraction of oil, gas, and minerals fragments and destroys Great Gray habitat in boreal forests. In North America's western mountains, the building of houses, cabins, and campgrounds breaks up or eliminates the owl's habitat, and grazing and off-road vehicles compact the soil, which collapses pocket gopher tunnels. Much of this development is occurring downslope of Great Gray nesting territories but within winter home ranges.

Great Gray Owls are also vulnerable to poisons targeting the rodents on which they feed. Strychnine is often used to poison pocket gophers in the western United States, and anticoagulant rodenticides such as those that contain warfarin are being used more frequently for other rodents. Although we do not yet know the full impact of such poisons on Great Gray populations, the owls are more likely to be vulnerable during irruptions, when they frequently hunt along fencerows in agricultural lands. Poisons containing warfarin are particularly problematic because they kill rodents slowly, increasing the likelihood that owls will ingest them in their prey and die by poisoning.

Great Gray Owls in both habitats are killed by collisions with vehicles. During winter irruptions they are particularly vulnerable. For example, during the irruption of 2004–05, the majority of Great Gray Owls killed in Ontario and Minnesota died as a result of collisions with autos. Since they hunt in treeless open areas, Great Grays often hunt alongside and across roads, where their low flight puts them in danger of being hit, especially at night. Finally, Great Gray Owls are quite vulnerable to the West Nile virus, which can kill them.

*After fledging hours earlier, a Great Gray Owl youngster with a piece of a branch stuck to its feathers pauses atop a snag it climbed.*

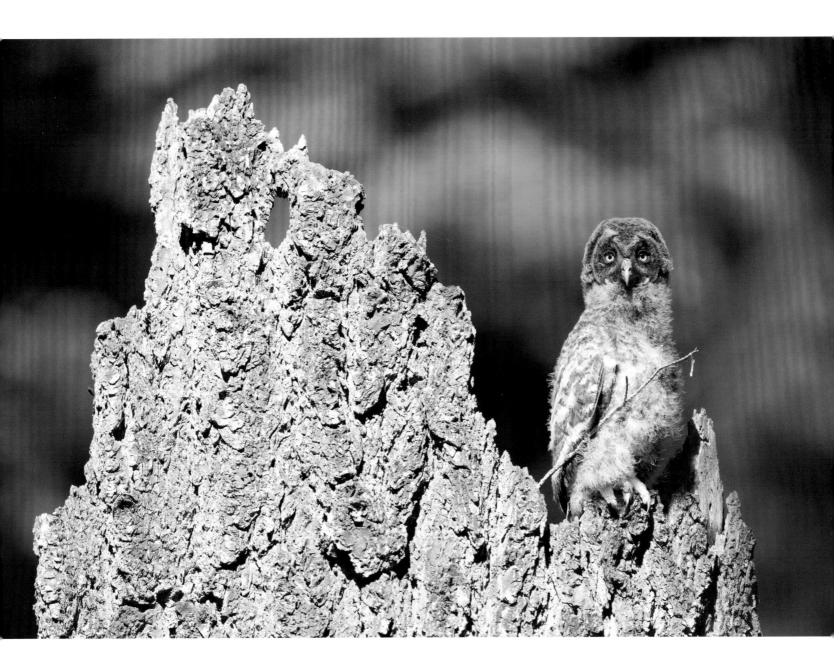

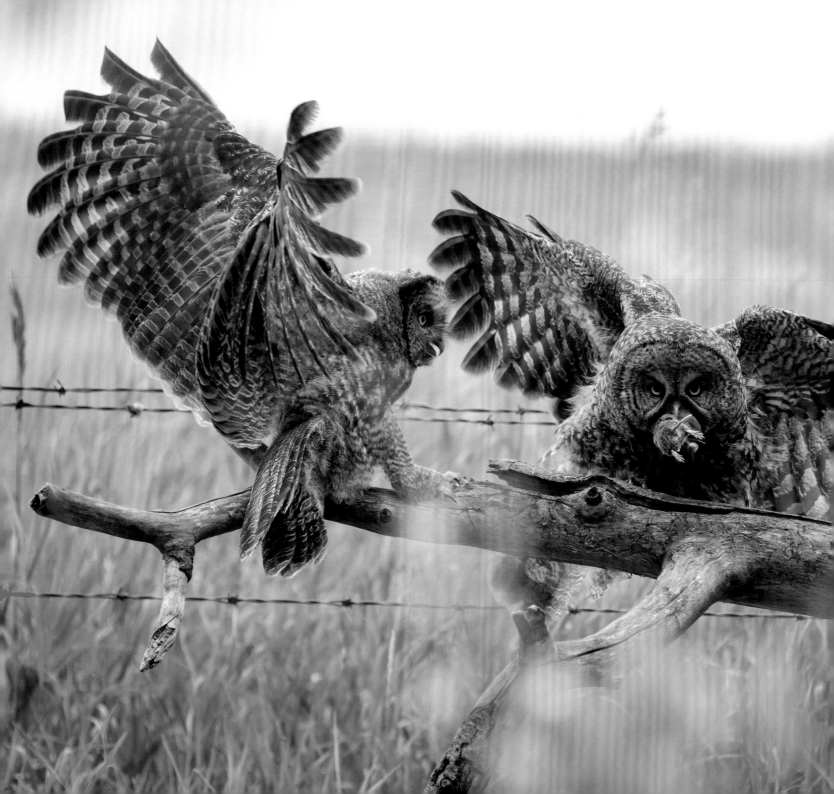

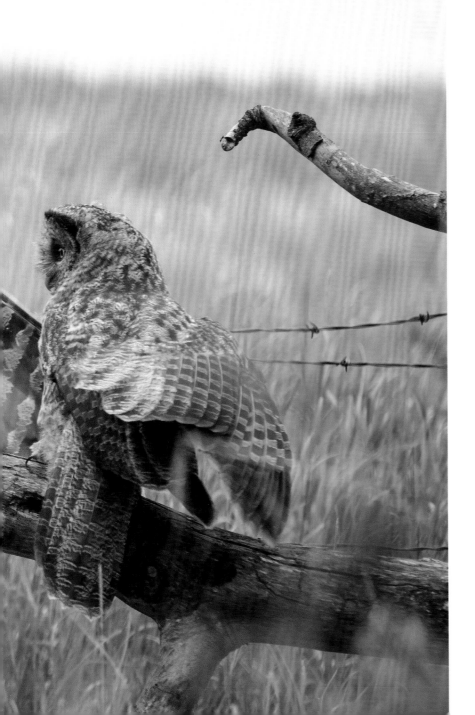

*Two fledglings mob their father to receive the gopher he is attempting to deliver. There is a lot of competition for food and often an explosion of feathers when adults feed older juveniles.*

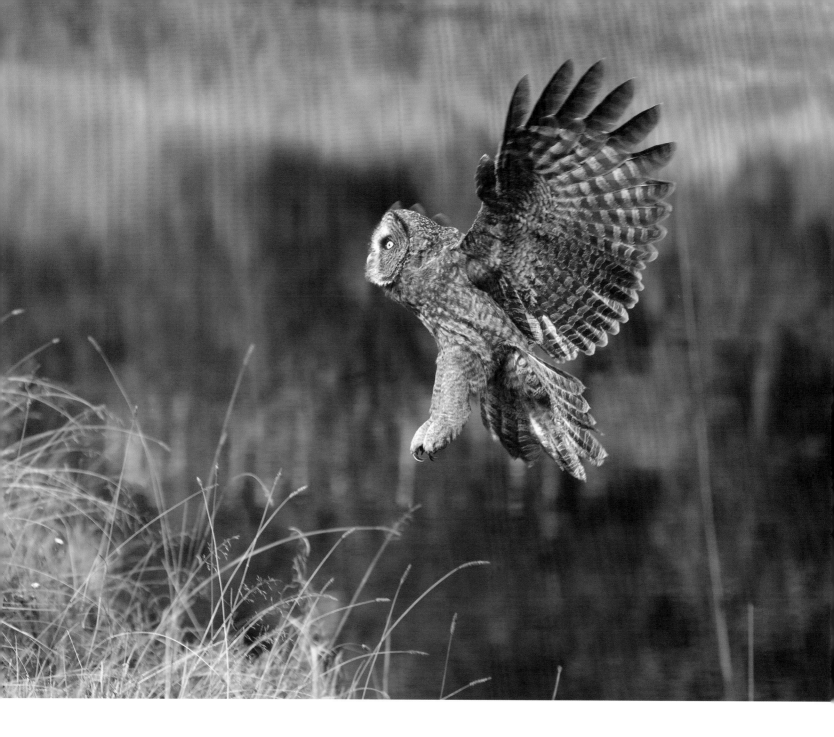

## *Taking Action*

When I hear a Great Gray's steady, pulsing call, I feel as if I am listening to the very heartbeat of the boreal forest. When one emerges ghost-like from the trees or its movements break its camouflage against bark, revealing its startling countenance, I am entranced, and I think this is true for many who see these owls in captivity, in the wild, or in strong photographic images. I believe our enchantment with these owls can motivate us to learn more about them, help preserve their habitats, and act mindfully in their presence.

Whenever we encounter Great Gray Owls, it is important to remember that they are wild animals, and although they may not seem to mind our presence, they are, at best, tolerant of us. Avoid getting too close, making them fly, or attempting to get them to come into view through recordings or food. Playing their calls can interfere with their ability to establish a territory, find food and mates, and breed successfully. Feeding or baiting owls can alter their behavior, causing them to spend time too close to human habitations and roads, where there is a greater chance of them being accidentally hit by vehicles.

If you are fortunate enough to live in Great Gray Owl habitat, you can help the owls by putting up a nesting platform. Artificial platforms are often used by owls for many years. You can find plans for a Great Gray Owl platform at www.nestwatch.org.

Landowners with Great Gray Owls nesting on their property must be cautious when thinning or cutting. Leave a larger uncut buffer around nest sites and retain leaning trees. Keep the overall size of cuts small, retain hunting perches in cut areas, and maintain an irregular boundary for the cut. Take care to maintain the canopy.

Most Great Gray Owls live out of our sight on US public lands, Canadian Crown lands, and commercial forestlands, and we generally encounter the owls only when they move outside those habitats. Even though we don't often see them, we should keep them in mind; they rely on us to become educated about their needs and to act to protect both them and their ecosystem. We must advocate for the owls' needs to be considered before forests are cut or thinned or meadows developed within

*A Great Gray Owl flies from a riverbank after a failed attempt at capturing a vole. Voles do well in grassy or herbaceous areas that are moist and open, making the treeless edges of ponds, lakes, or slow-moving rivers productive hunting sites.*

their habitats. Because the Great Gray is considered an indicator species for the health and function of mature forests in both the boreal and the western mountains, its habitat needs have been a necessary consideration for timber harvests in many areas, including Manitoba, Minnesota, and the Pacific Northwest. In Washington, Oregon, and Northern California, both the US Forest Service and the Bureau of Land Management have, in the past, designated the Great Gray Owl as a species to consider when managing forests because of its association with late-successional and old-growth forests. Unfortunately, pressures to harvest more timber have caused the Great Gray to lose this designation, along with the protections it afforded, in some areas. We need to exert pressure on officials to restore such designations and expand protections for the owl's habitats. It is up to us to continue challenging the most threatening resource-harvesting and development plans and to intensify our efforts to forestall climate change.

To achieve these goals, we must stay informed and be willing to advocate politically and economically. It is impossible to do this alone. Consider joining a local or national conservation organization that can provide guidance on how our voices, votes, and investments can make the most impact. Communicate with your local, state, provincial, and national government representatives; vote for policies and candidates who fight for public lands and against climate change; and donate to organizations and invest in corporations that support these goals.

I hope that we continue to be captivated by the Great Gray Ghost and that together we can learn more about this charismatic animal, help educate others, and advocate for policies that protect its habitats and ensure its survival.

*Great Gray Owls become much more active once the sun drops below the horizon and usually remain so until after the sun has risen, although they may be active at any time, particularly when raising young.*

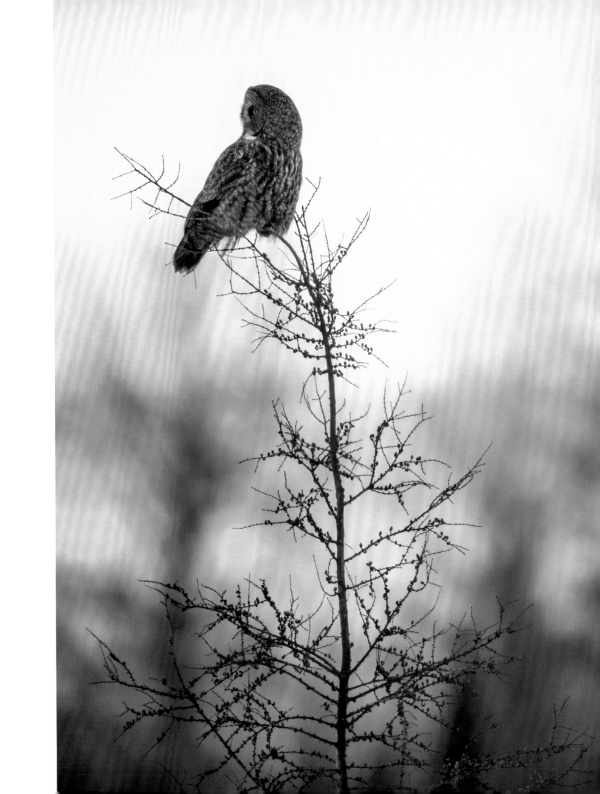

*The low flight path of a Great Gray Owl helps conceal it from a distance as it glides slowly over grassy fields, cattails, and water.*

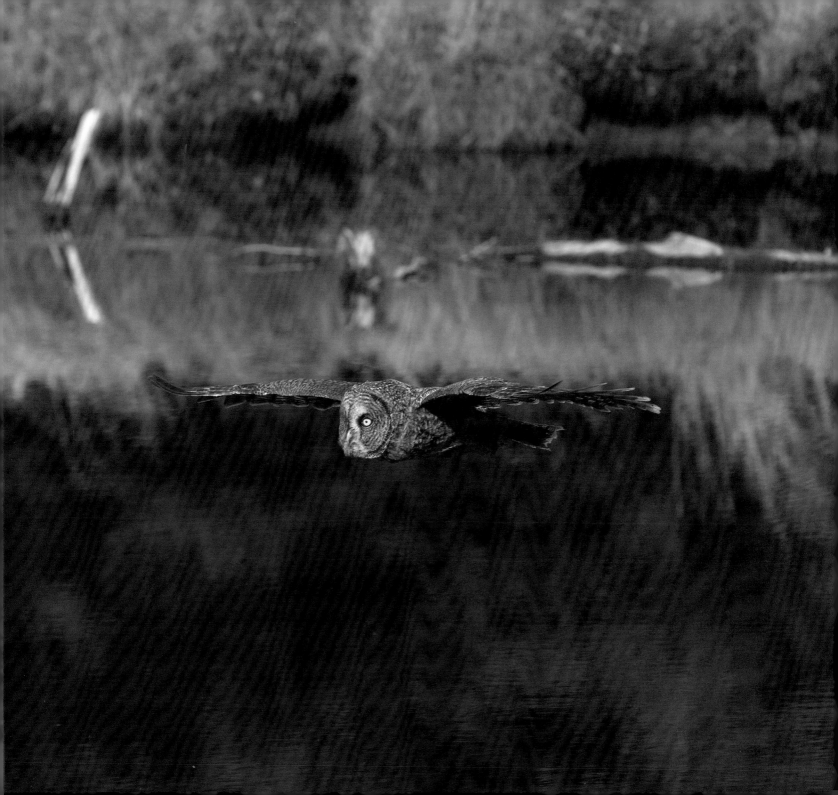

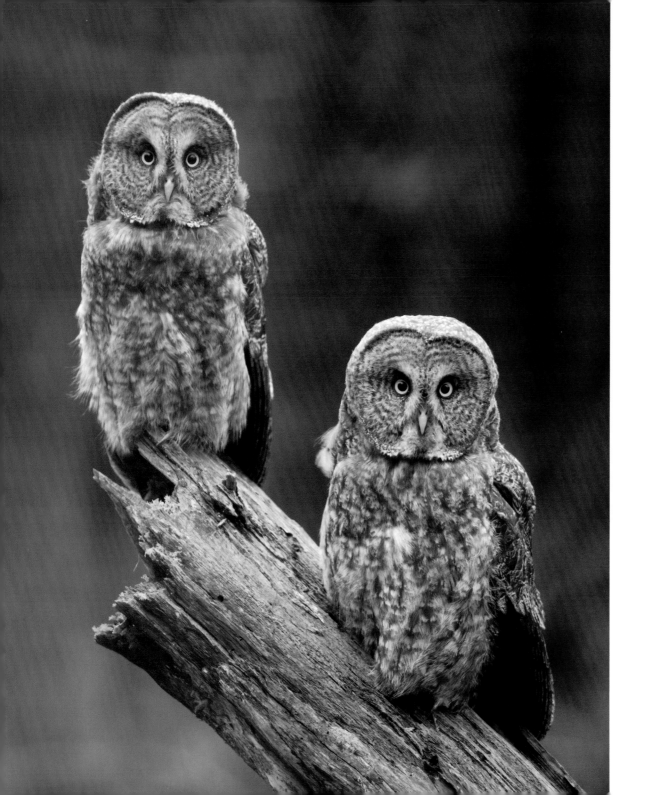

# Field Guide to the Great Gray Owl

*When Great Gray Owls first leave the nest they normally roost on their own trees and attempt to climb progressively higher into the canopy. But as they become capable of controlled flight, they will often roost near one another and sit side by side as they beg to be fed.*

**DESCRIPTION:** A large gray owl with a distinctive facial disk and small, yellow eyes; 25 to 33 inches long, with a wingspan of 54 to 60 inches.

**SIMILAR SPECIES:** Larger and grayer than the Barred Owl or Spotted Owl, with yellow rather than dark brown eyes.

**INTERESTING FACT:** The largest owl (in length) in North America.

**NORTH AMERICAN DISTRIBUTION AND HABITAT:** A year-round resident of boreal forests of Canada and Alaska and conifer and mixed-conifer forests of the western mountains. Boreal Great Gray Owls periodically irrupt south, east, or less commonly north in some winters, while some western Great Grays move downslope.

■ NORMAL WINTER AND BREEDING RANGE

**NESTING:** A platform-nesting owl that nests on broken-topped trees, mistletoe brooms, and stick nests of Northern Goshawks in particular and also other hawks and ravens; lays one to five eggs.

**VOCALIZATION:** Series of low *hooo* calls.

**CONSERVATION STATUS:** Sensitive in the United States, at the edge of its range, where Washington, Oregon, Idaho, Montana, Wyoming, and California afford it special conservation status.

# Acknowledgments

It takes a team to publish a strong book and I am grateful to have benefited from a talented group. From the multi-talented Helen Cherullo's initial embrace of the concept, Kate Rogers' insightful collaboration at each juncture, Linda Gunnarson's attention to detail and understanding of natural history, the continuous guidance and subtle improvements implemented by Janet Kimball and, finally, the beautiful design work by Kate Basart, the team was top notch. And I am grateful to friends Jamie Acker and Jean Tuomi for offering helpful suggestions after reading my early manuscript.

*Food deliveries often involve adults colliding as the prey is moved between bills while the young screech. However, at other times the exchange is gentle and resembles those made during courtship with the adults meeting bill to bill and chittering. Here, one of three nestlings faces the male that is delivering the prey atop an abandoned Northern Goshawk nest.*

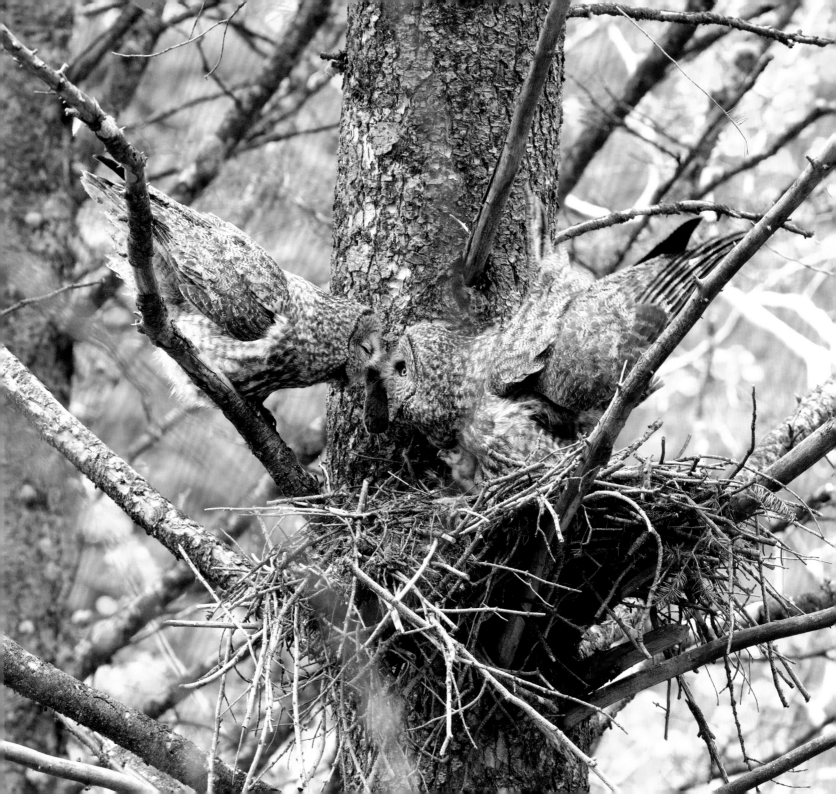

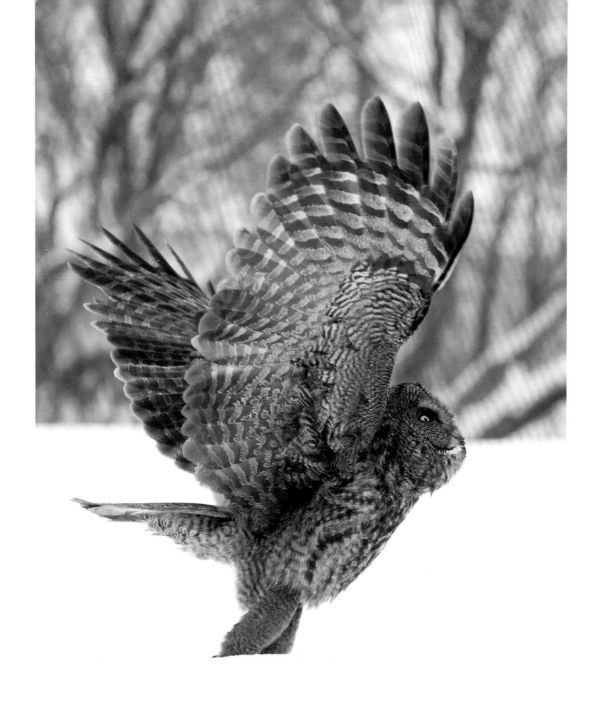

# About the Author

JON PURCELL

PAUL BANNICK is an award-winning author and photographer who captures authentic images to inspire wildlife education and conservation. He is the author and photographer of two best-selling bird books, *Owl: A Year in the Lives of North American Owls* (Braided River, 2016) and *The Owl and The Woodpecker: Encounters with North America's Most Iconic Birds* (Mountaineers Books, 2008). *Owl* received the gold medal in the animals category of the 2017 Independent Publisher Book Awards, and *The Owl and the Woodpecker* was a finalist for the Washington State Book Award.

Paul's photography has won awards from several prestigious contests, including those hosted by *Audubon* magazine and the International Conservation Photography Awards. His work is prominently featured in bird guides from Audubon, Peterson, and the Smithsonian, among others, and has appeared in a variety of publications including the *New York Times, Audubon, Sunset, Nature's Best Photography Magazine,* and *National Geographic* online. Additionally, his photography has been the subject of many regional and national television and radio pieces as well as several North American traveling exhibits.

An active public speaker, Paul presents multimedia owl and woodpecker programs at events throughout the United States and Canada every year. He serves as the director of major gifts for Conservation Northwest, a Seattle based nonprofit dedicated to protecting, connecting, and restoring wildlands and wildlife from the coast of Washington to the Rockies of British Columbia.

More of his work can be seen at paulbannick.com, on Facebook at Paul Bannick Photography, and on Instagram @paulbannick.

*With legs extended, wings raised, and destination perch identified, a Great Gray Owl prepares to take flight.*

# A Note about the Photography

I strive to capture authentic moments of natural behavior in a manner that has the most minimal impact on the subject. This allows me to photograph nature as it *is* rather than as we *wish* it appeared. I do not bait or lure subjects, and, unless explicitly noted, all of my images feature wild, unrestrained subjects. None of the images were taken with camera traps. I do not edit out distracting branches, birds, or other elements, and remove nothing but dust from the camera's sensor. I apply only global electronic modifications such as minimal levels, contrast, noise reduction, or saturation to the entire image to match what I witnessed and do not create composite images.

The images in this book were captured with Canon and Sony cameras with 600mm f4, 24-70mm f2.8, and 100-400mm lenses. Carbon tripods and gimbal heads were used for most images.

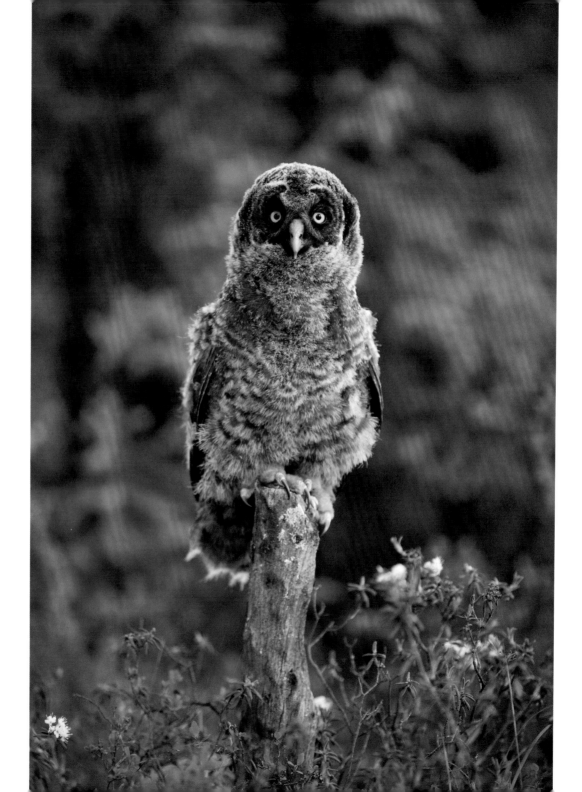